Geometrical Patterns

by the same author

PATTERNS IN SPACE
TOYS FROM BALSA
TISSUE PAPER CRAFT
YOU CAN MAKE A STRING PUPPET
TAKE AN EGG BOX : How to make some
 interesting models
MASKS AND HOW TO MAKE THEM
CLEVER HANDS : A Book of Arts and Crafts
 for Boys and Girls
YOUR BOOK OF MODELLING
YOUR BOOK OF HERALDRY

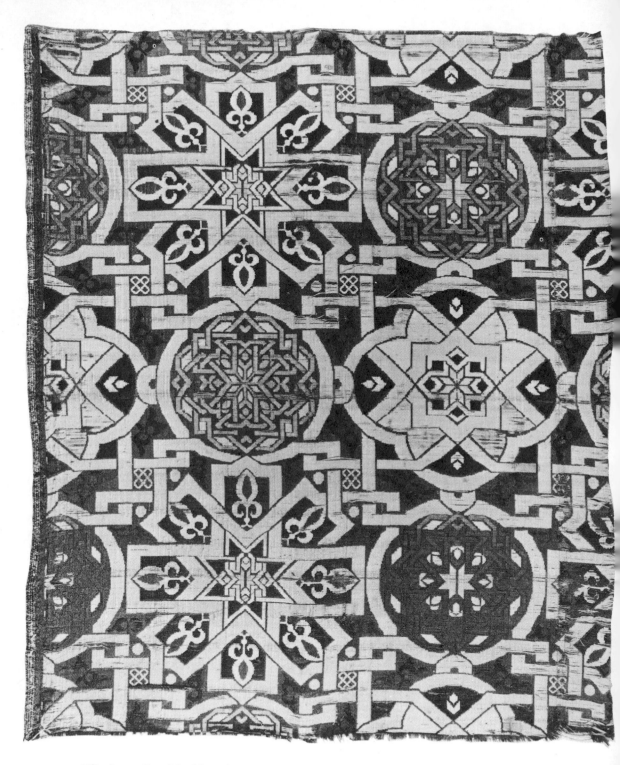

Silk tissue, Spanish, fifteenth century
By courtesy of the Victoria & Albert Museum

Geometrical Patterns

RICHARD SLADE

Faber and Faber Limited
London

First published in 1970
by Faber and Faber Limited
24 Russell Square London WC1
Printed in Great Britain by
Latimer Trend & Co Ltd Whitstable
All rights reserved

ISBN 0 571 08793 0

© 1970 by Richard Slade

Contents

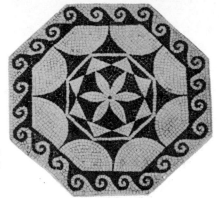

Geometrical pavement from Carthage
By courtesy of the Victoria & Albert Museum

Illustrations

Ashanti tribe gold ornament,
showing a skilful use of geometrical pattern
By courtesy of the British Museum

11

Introduction

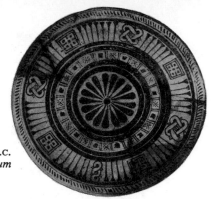

Dish from Camirus, 650–600 B.C.
By courtesy of the British Museum

The story of geometrical pattern takes us quite a long way back in time. Long before the men of prehistory who made the life-like paintings of animals on the walls of caves in France and Spain, others had carved lines into geometrical forms on horn and bone. In the Moravian Museum, in Brno, there is a mammoth tusk 25,000 years old which is engraved with these patterns in the form of a woman.

Later, as civilization developed, more and more use was made of geometrical pattern. It was used in weaving, on pottery, on weapons and armour, in jewellery, in the decoration of clothing and of architecture. It is found in the societies of all kinds and conditions of men: in Stone Age tribe and Classical Athens; among Eskimos and South Sea Islanders; on Chinese and native African works of art. It stretches around the world as well as into man's remote past.

This does not mean that the use of geometrical pattern has been thoroughly exhausted. One of the surprising facts about simple geometrical figures is the seemingly limitless variety of shapes which can be made from them. New use for these shapes is also constantly being discovered. Television provides a fresh example of a new use of geometrical pattern: moving, translucent cubes and prisms in front of the camera create complex and ever-changing geometrical patterns on our screens. In nature the infinite variety of the snow crystal—which is based on the hexagon—demonstrates the possibilities of invention.

It is a form of drawing which anyone who is able to use a ruler and compasses can enjoy. It does not demand the freehand skill that may seem beyond the reach of most of us. Nevertheless this does not prevent the work being original and creative. The geometrical instruments we use can be considered as the tools of creation.

13

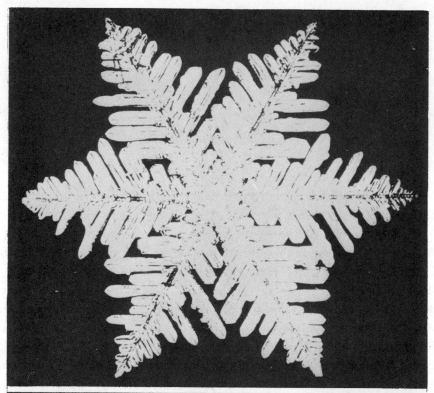

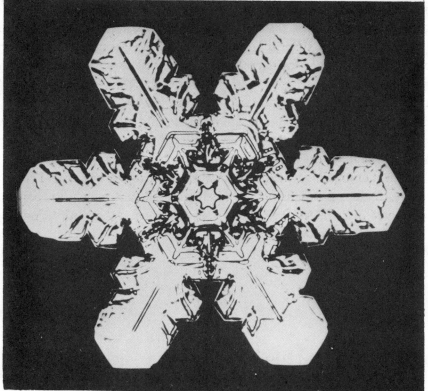

Geometrical
pattern in nature:
snow crystals

1 · Tools and Materials

The only really necessary drawing equipment, apart from paper, is a pencil, a ruler and compasses. These can be of the sort used in schools. All the patterns in this book can be drawn with these.

But we know that a competent workman takes a pride in his tools, and the possession of a good geometry set, for example, gives pleasure as well as assisting the work. Such geometry sets may be considered expensive, yet we have to remember that one of these when properly used will last a lifetime. Aunts and uncles may like to note that they make excellent presents.

PLATE 1. **Drawing Equipment**

1. Compasses. The one shown here has a detachable leg. The joint holding the lead can be removed. It can be replaced by another steel point to make the compasses into dividers; or it can be replaced by the part shown at 3, which is a pen attachment. More expensive compasses have joints on both legs which can be bent to give an easier drawing of a wide radius. This kind is preferable.

2. Dividers. This saves time when measuring a number of spaces of equal length. It also adds accuracy to measurement because of the needle-sharp points.

3. Pen attachment. These work very well but call for a little skill. If you have never used one, then practise with it on some scrap paper. The opening at the tip of the pen is adjustable and is opened or closed by means of the screw knob at the side. A small amount of drawing ink is put between the arms of the pen. With some bottles of drawing ink a dropper is provided for this purpose; otherwise a small medicine dropper will do. Do not overfill the space. Practice will give you the experience to set the right opening at the tip of the pen.

4. Pen. What has been said about the pen attachment also applies to this.

5 and 7. Two set squares. These are for drawing perpendiculars and parallels and are very useful in pattern work.

15

6. Drawing-pins. Drawing-paper is usually attached to a drawing-board with pins to prevent the paper slipping about. Another means of securing the paper is with clips or adhesive tape.

8. Rubber. This should be kept clean. Its main purpose is to remove pencil guide lines after the ink lines have been drawn in. To correct a mistake made in ink the point of a sharp penknife can be used very carefully to remove most of the ink; a rubber can then be applied and finally the spot can be gone over with a fine brush and white drawing-ink.

9. Abrasive board. These can be bought but are quite easily made. Glue a strip of fine emery or glasspaper to a piece of wood or strong cardboard. You will find it very handy for keeping an edge or point on your pencil.

10. Pencil. This must always be sharp for measuring or drawing. You can sharpen it to a point or a chisel edge, whichever you prefer.

11. French curves. These were invented by Professor French, a mathematician. They are useful for drawing geometrical shapes which are otherwise difficult to achieve. Messrs. Dargue of Halifax make a strong and moderately-priced set of four. One side of the curves should be bevelled so that when you draw with ink the edge is raised from the paper to prevent blots and smudging. They can be used for inventing new shapes.

12. Protractor. This is usually in the form of a semi-circle, although rectangular ones are just as good. It is used for measuring angles and is divided into 180 degrees.

13. Ruler. Take care not to damage the edges of this. Use it only for measuring and drawing lines. One side should have bevelled edges so that when you are drawing lines in ink the edge of the ruler can be raised from the paper, or smudging is likely to occur. In any case have a piece of rag handy and always wipe the edge of the ruler after using ink.

14. Drawing-board and T-square. If you buy a drawing-board or make one, you must be quite sure that the edges are straight and square; the angles in each corner must be right angles. Otherwise the T-square will not line up accurately. Drawing-paper should be fastened securely and squarely to the board. The T-square consists of two pieces of wood joined at right angles in the form of a T. The short arm of the T goes against the edge of the drawing-board. It is then a simple matter to draw horizontal lines across the paper, once the points of measurement have been marked. By standing a set square on the T-square perpendiculars and parallels can also be quickly drawn in.

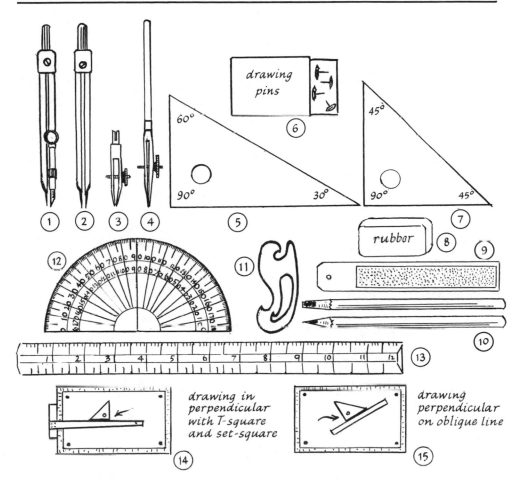

Plate 1. **Drawing Equipment**

15. This shows a ruler and set square in use on the board. This is an easy method of drawing perpendiculars and parallels on an oblique line. The ruler must be kept steady. When drawing any lines with a ruler, remember to hold the ruler firmly and the pencil lightly.

Mapping and lettering pens, coloured drawing-inks—they should be drawing-inks and not the kind used for ordinary writing—a fine brush and a penknife can be added to the above equipment. This equipment does not have to be purchased all at once but can be built up gradually.

B

Tools and modelling materials

Craft tool. This is a very sharp knife for cutting card and cardboard. It is used with a straight-edge, which is a steel ruler or a wooden ruler with a metal edge. The material to be cut should always be placed on a flat surface. The cutting process will usually mark this surface, so that a special cutting surface such as a large piece of thick cardboard or hardboard may be necessary. Take care when using the craft tool. Because it is so sharp, if it slips it could make a nasty wound. With this in mind, hold the straight-edge firmly and keep your fingers away from the cutting edge. Hold the knife firmly, do not press too hard on the material being cut and draw the knife slowly along the line marked for cutting.

Scissors. These are very necessary and can be used instead of a craft tool and straight-edge, as well as for the many other cutting operations in cardboard modelling. A large pair for heavy work and a small pair for light work is ideal, but a large pair will do most jobs.

Adhesive tape. An adhesive tape such as Sellotape is useful for joining edges. Gummed paper or strips of paper and paste will do as well.

Paste and glue. A paste made from powder or cellulose can be used for light work. Thick cardboard requires a white glue, such as Copydex. Tube glue may also be necessary for some jobs: make it tacky before pressing surfaces together.

Pliers. A small pair of pliers is necessary for cutting and shaping the pieces of wire when making mobiles from your models.

Paints and brushes. Opaque colours are usual for pattern work. These can be bought as tempera powder, tempera blocks, tempera liquid colours, poster colours or as tube gouache colours. Brushes of soft hair are best for pattern work. With regard to size, a general rule is: the smaller and more intricate the pattern, the smaller the brush. Large areas are more quickly filled in with large brushes. But as long as it does the work efficiently, use the kind of brush you prefer.

Paper, card and cardboard. For practice work a cheap paper such as white shelf paper is very suitable. First cut it to the size you require. When you wish your work to be more permanent, use a good-quality drawing-paper. This can be bought in large (Imperial) sheets and cut to the required size. A large piece of

thin card folded in two will make a simple folder for your work. White card and cardboard can also be used for pattern work.

For our purpose, the distinction between card and cardboard is that card is thin and easily folded, while cardboard is stiff and tends to crack if you fold it without first scoring a fold line. For small models card is quite strong enough and will keep its shape. For large models cardboard will probably be necessary.

A variety of cover papers can be used for decorating solids. You can make your own, painting or stamping patterns on it. Decorative wrapping-paper, such as that sold for wrapping gifts, metallic papers, gummed coloured papers, and wallpaper are some of the papers you might wish to try.

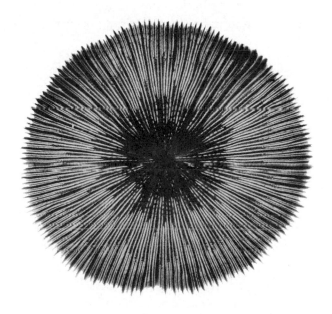

Geometrical pattern in nature: coral formation with radiating lines
By courtesy of the British Museum (Natural History)

2 · Terms and Figures

Only a little knowledge of elementary geometry is necessary to draw the patterns set out in this book. The terms and figures are quite straightforward. The meaning of terms has been kept as clear as possible and the diagrams have been drawn to fill in what a simple definition may have left out. For those interested, full definitions, theorems and proofs can be found in geometry textbooks.

PLATE 2. Basic Figures

The basic geometrical figures are the point, the line, the plane and the solid. The cube (a hexahedron) contains all these figures. It has points, lines, planes, and it is a solid.

1. Point. This is said to have position but not size.

2. Line. This is said to have length but neither breadth nor thickness.

3. Plane. This is said to have length and breadth but not thickness. It is two-dimensional.

4. Solid. This has length, breadth and thickness (depth). It is three-dimensional. On 4, *a, b, c* and *d* are points; *ab, bc, cd* and *da* are lines; *abcd* is a plane (or surface); and the whole is a solid.

5. Angles. These are formed when two lines meet. The circle contains 360°, shown here as four right angles (the symbol for a degree is a tiny o).

6. Right angle. This has 90°, and is formed when one line is perpendicular to another.

7. Obtuse angle. Made when two lines form an angle greater than 90°.

8. Acute angle. Made when two lines make an angle less than 90°.

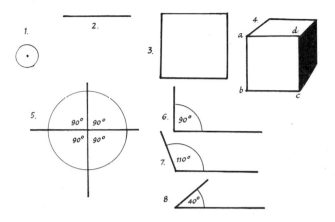

Plate 2. **Basic Figures**

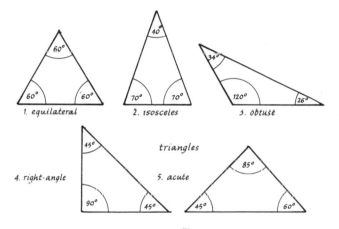

Plate 3. **Plane Figures**

PLATE 3. **Plane Figures**

　　1. Equilateral triangle. This has three equal sides and three equal angles.

　　2. Isosceles triangle. This has two of its sides equal and two of its angles equal.

　　3. Obtuse triangle. This has one of its angles greater than 90°.

　　4. Right-angle triangle. This has one of its angles a right angle (90°).

　　5. Acute triangle. This has each of its angles less than 90°.

quadrilaterals

square

rectangle

circle

pentagon

hexagon

ellipse

Plate 4. **Plane Figures**

PLATE 4. **Plane Figures**

1. Square. This has four equal sides and four right angles.

2. Rectangle. This has its opposite sides equal and all its angles right angles. The square and the rectangle are also called quadrilaterals, plane figures bounded by four lines.

3. Circle. This is a closed curve with all its points equally distant from its centre.

4. Pentagon. This, a regular pentagon, has five equal sides and five equal angles.

5. Hexagon. A regular hexagon has six equal sides and six equal angles.

6. Ellipse. If a cone (plate 5, figure 8) is cut through by an inclined plane, the outline of the surface so made is called an ellipse.

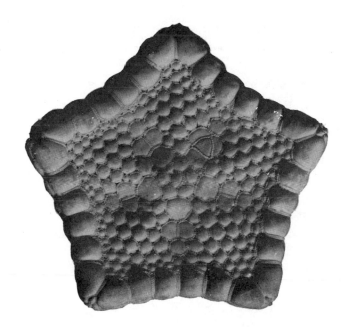

Geometrical pattern in nature: the patterned pentagon of a starfish
By courtesy of the British Museum (Natural History)

PLATE 5. **Solids**

A solid bounded by planes is called a polyhedron. A regular polyhedron is one that has all its surfaces (planes) alike. There are five regular polyhedra: the tetrahedron, the hexahedron, the octahedron, the dodecahedron and the icosahedron. Albrecht Dürer, a famous German artist of the sixteenth century, showed how models of these could be made out of stiff paper. This is the method shown in this book.

Since the full definitions of solids tend to confuse rather than to make clear, only a simple reference is given here and this is helped by the illustrations.

1. Tetrahedron. This is a solid bounded by four equal equilateral triangles.

2. Hexahedron. This is a solid bounded by six equal squares.

3. Octahedron. This is a solid bounded by eight equal equilateral triangles.

4. Dodecahedron. This is a solid bounded by twelve regular pentagons.

5. Icosahedron. This is a solid bounded by twenty equal equilateral triangles.

6. Cylinder. This has three surfaces: two end surfaces which are equal circles, and a main surface which fits the circumference of each end piece.

7. Hexagonal prism. A prism is named according to its end pieces. The two end pieces give the number of sides. The hexagonal prism has two equal hexagons as end pieces and therefore six sides.

8. Cone. This has a circle for an end piece or base, and the other end comes to a point.

9. Hexagonal pyramid. A pyramid is named according to its end piece or base. This has one hexagon as an end piece and the other end comes to a point. It has six sides.

10. Triangular prism. This has three sides with two equal triangles as end pieces.

11. Cylindroid. This is a cylinder made with two equal ellipses as end pieces.

12. Sphere. This is simply a ball with all its surface points equally distant from its centre.

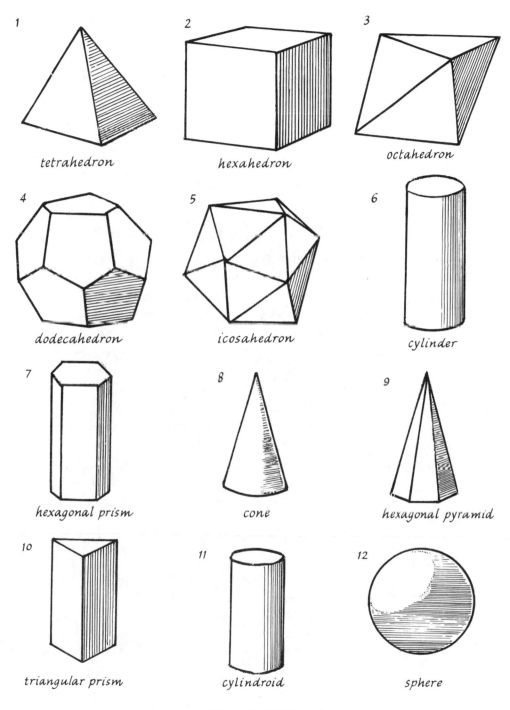

1 tetrahedron

2 hexahedron

3 octahedron

4 dodecahedron

5 icosahedron

6 cylinder

7 hexagonal prism

8 cone

9 hexagonal pyramid

10 triangular prism

11 cylindroid

12 sphere

Plate 5. **Solids**

3 · Lines

There are really only two kinds of lines, straight and curved. From these all other kinds of lines are constructed.

PLATE 6. Types of Lines

1. A straight line is defined as the shortest distance between two points; here between *a* and *b*.

2. A curved line is a line on which no part is straight.

3. A zigzag line is made up of a number of straight lines.

4. A horizontal line is a flat or level line (level with the horizon).

5. A perpendicular line is a line at right angles to a horizontal line. It can also be called a vertical or an upright line. A perpendicular can also be drawn at right angles to an oblique line.

6. An oblique line is neither horizontal nor vertical.

7. In a quadrilateral a diagonal is a straight line joining opposite corners. The term can also be used with polygons.

8. Parallel lines. These are opposite lines which never meet. Single-track railway lines are an example of these.

HERALDIC LINES

9 to 18. These are used in heraldic designs, and can be used in geometrical pattern work.

19. Radiating lines. These may be any number of lines which branch out from a common centre. They need not necessarily be straight.

20. Spiral. There are different kinds of spirals. The simplest one to draw is shown here and is made up of semi-circles.

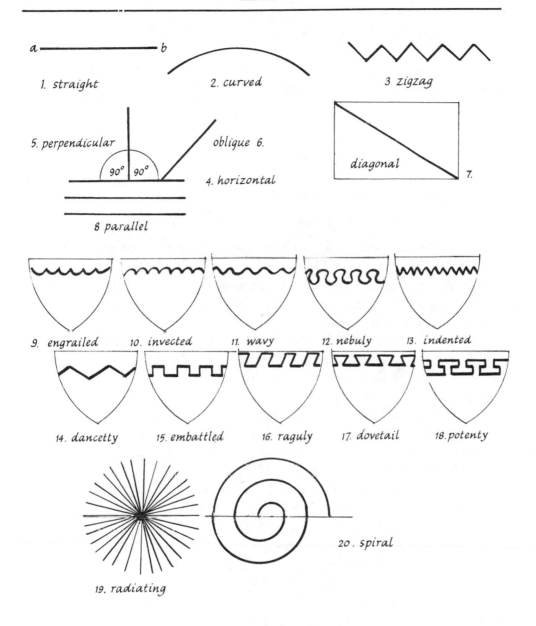

1. straight 2. curved 3 zigzag

5. perpendicular oblique 6.

90° 90°

4. horizontal

diagonal 7.

8 parallel

9. engrailed 10. invected 11. wavy 12. nebuly 13. indented

14. dancetty 15. embattled 16. raguly 17. dovetail 18. potenty

19. radiating 20. spiral

Plate 6. **Types of Lines**

4 · Plane Figures

There is usually more than one method of drawing the plane figures in geometry. Simple methods are given here which the drawings illustrate.

PLATE 7. **Method of drawing figures**

1. Perpendicular. This is made with a ruler and compasses. Draw a straight line *ab*. Place point of compasses on *a* and make the arc *be*. With the same radius place point of compasses on *b* and make the arc *af*. Find centre of line *ab*; call this point *d*. Draw a straight line from *d* to where the arcs cut at *c*. *dc* is then the perpendicular.

2. Bisecting a line. Draw the line *dc* to be bisected. With the point of the compasses at *c*, draw the arc *hi*. Using the same radius, with the point of the compasses at *d*, draw the arc *fg*. Draw the line *ab* through the points where the arcs cross. *ab* is the bisecting line.

3. Perpendicular. This is drawn with a protractor. Draw a straight line *ab* and find the centre *d*. Place the protractor on the line, with the centre of the protractor at *d*. Make a point at the 90° mark on the protractor. A line drawn from point *d* through the 90° mark to *c* will give a perpendicular.

4. Parallels. Made with ruler and compasses. Draw a straight line *ab*. Find the centre *e*. Keep the compasses at a set radius. With the point of the compasses at *a*, draw the arc *hi*; with the point at *e*, draw the arc *fg*; with the point at *e*, draw the arc *lm*; with the point at *b*, draw the arc *jk*. A straight line drawn through the points where the arcs cut will be parallel to *ab*.

5. Parallels. Made with a set square and a ruler. Draw a straight line *ab*. Place the set square at right angles on this and draw the line *ef*; do the same for *gh*. Measure the same lengths on *ef* and *gh*. A straight line drawn through these points will be parallel to *ab*.

6. Drawing angles. Made with a ruler and protractor. On any given straight line place the centre of the base of the protractor at the point from which

28

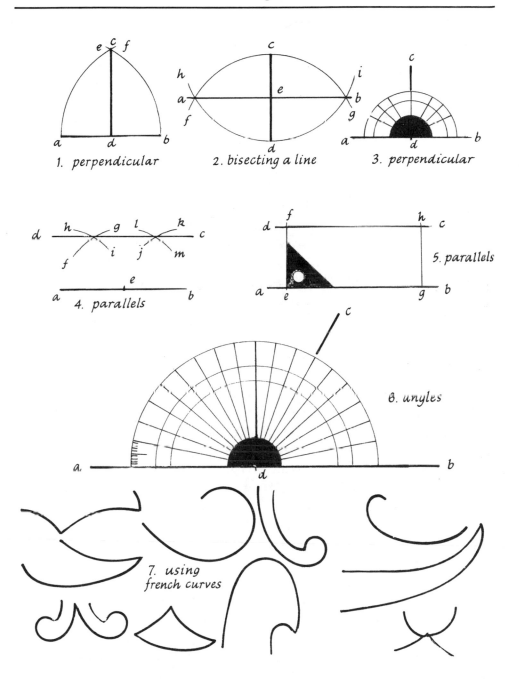

1. perpendicular 2. bisecting a line 3. perpendicular

4. parallels 5. parallels

6. angles

7. using
french curves

Plate 7. **Method of drawing figures**

you wish the angle to begin. Use the protractor to mark a point at the number of degrees required in the angle. A line drawn, say, from point *d* to point *c* through the point given by the protractor will form the angle required.

 7. *Using French Curves.* A few examples are shown. These Curves are used to draw lines and figures which would otherwise require considerable skill or geometrical knowledge. They can be used to create geometrical patterns.

PLATE 8. **Method of drawing figures**

 1. *Equilateral triangle.* Given the length of one side *ab*, open the compasses to the radius *ab*. Draw the arcs *de* and *fg* with the point of the compasses at *a* and *b*. Join *ac* and *bc*, *c* being the point where the arcs cross.

 2. *Isosceles triangle.* Given the length of one side *ab*, open out the compasses to the required length of the other two sides. With the point of the compasses at *a* and *b*, draw the arcs *de* and *fg*. Join *ac* and *bc*, *c* being the point where the arcs cross.

 3. *Right-angle triangle.* Given the length of one side *ab*, extend this line to a point *e*. Find the middle of the line *ab*. With a radius *af* mark point *d*. With the point of the compasses at *d* and *f*, mark the arcs *gh* and *ij*. Join *ac* and *bc*, *c* being where the arcs cross.

 4. *Obtuse triangle.* This has one angle larger than 90°. Given the line *ab*, extend it to a point *d*. Place the protractor on the line *db*, with the centre at *a*, Mark the number of degrees required (in the example it is 120°). Draw line *ac* through the degrees mark. Join *bc*.

 5. *Acute triangle.* This has all its angles less than 90°. Given the base line *ab*, extend it to *d*. With the protractor on the line *db*, and the centre at *a*, mark off number of degrees required (in the example it is 55°). Draw the line *ac* through the degrees mark. Join *bc*.

 6. *Square.* This can be drawn with protractor, set square or compasses. Here the compasses are used. Given the length of one side of the square *ab*, extend this to *e* and *q*. Find the centre of *ab*; call this *g*. With radius *ag* draw point *f* from *a*; draw point *p* from *b*. From points *f* and *g* draw the arcs *hi* and *jk*. From the points *g* and *p* draw the arcs *lm* and *no*. Draw the lines *ad* and *bc*, the same length as *ab*, through the points where the arcs cross. Join *dc*.

 7. *Rectangle.* This is drawn similarly to the square, except that the lines *ad* and *bc* will be longer than *ab* and *dc*.

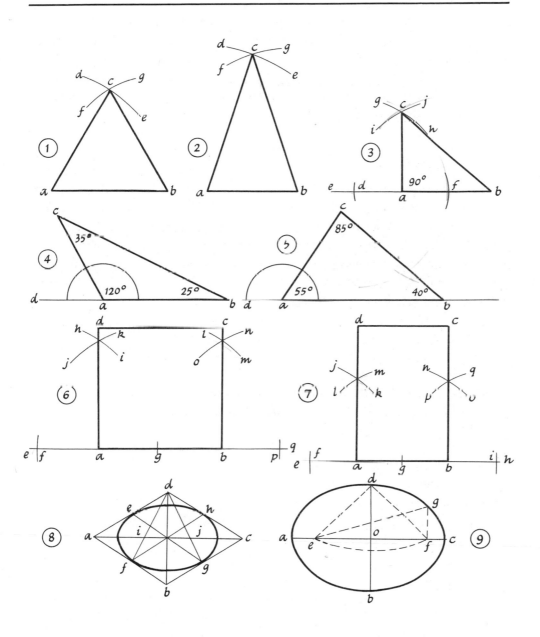

Plate 8. **Method of drawing figures**

8. Ellipse. This shows the four-arc method of drawing an ellipse. This does not give a true ellipse but it is sufficiently accurate for our purpose. Draw a straight line *ac*, say 2½″ long. Draw a line vertically through the middle of this, *bd*, say 1½″ long. Join points *a*, *b*, *c* and *d*. Find the centres of lines *ab*, *bc*, *cd* and *da*; call these points *e*, *f*, *g* and *h*. Join *fd*, *gd*, *fh* and *ge*. With the radius *ie* and the point of the compasses at *i*, draw the arc *ef*. With the radius *jh* and the point of the compass at *j*, draw the arc *hg*. With the radius *be* and the point of the compasses at *b*, draw the arc *eh*. With the radius *dg* and the point of the compasses at *d*, draw the arc *fg*. These four arcs form an approximate ellipse.

9. Ellipse. This shows the pin and thread method. Draw a straight line *ac*. Draw another, shorter line *db* vertically through the centre of this. The points *e* and *f* will be at the same distance from *o* as *d* and *b*. Fix three pins in firmly at points *d*, *e* and *f*. Tie a piece of thread round these pins. Remove the pin at *d*, and replace it with the point of your pencil. Now move the pencil round, keeping the thread stretched, and this will draw an ellipse. A little practice is needed since the thread may tend to slip.

PLATE 9. **Method of drawing figures**

More complicated figures, that is figures with more sides, can be made by dividing the circumference of a circle into equal parts. The points of division are then joined by straight lines, as in the diagrams. These figures will be regular polygons.

However, two ways of drawing a pentagon are shown. The first, *No. 1*, is drawn without using a circle.

1. Pentagon: five sides. Draw a line *ab* the length of one of the sides of the required pentagon. Extend this to *f*. Find the middle point *g*. With the point of the compasses on *b* and the radius *gb*, mark *h*. With the point on *g* and then on *h*, draw the arcs *lm* and *jk*. Draw the perpendicular *nb*. With the radius *ab* and the point of the compasses on *b*, draw the arc *ao*. With the point on *g* and the radius *go*, draw the arc *oi*. With the point on *b* and the radius *ai*, draw *tu*. With the point on *a* and the radius *ai*, draw *vw*. The compasses are now set to the radius *ab*, and kept to this radius for the following. With the radius *ab* and the point of the compasses on *d*, draw *rs*; with the point on *b*, draw *pq*; with the point on *a*, draw *za'*; with the point on *d*, draw *xy*. Join points *b*, *c*, *d*, *e* and *a* with straight lines to make a pentagon.

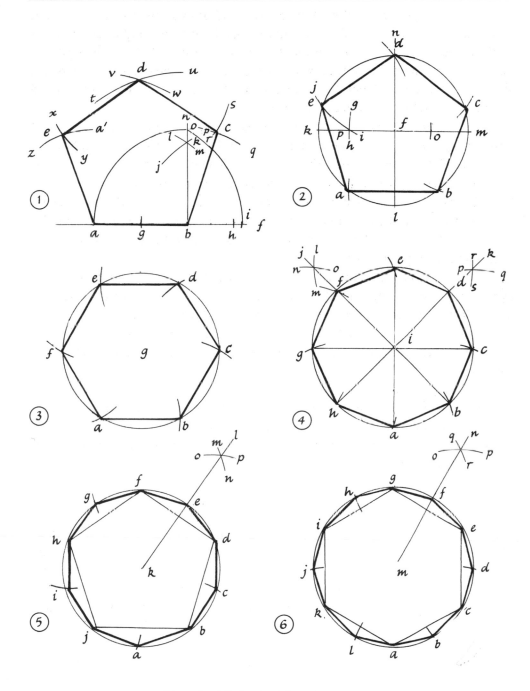

Plate 9. **Method of drawing figures**

G

2. Pentagon: five sides. Draw a circle and draw in the two lines *km* and *ln* crossing at right angles. Find the middle point between *f* and *m* and mark it *o*. With the point of the compasses at *o* and the radius *od*, draw *gh*. With the point at *d* and the radius *dp*, draw the arc *ij. de* is now the length of one of the sides of the pentagon. Open the compasses to that radius and mark off *a*, *b* and *c*. Join *a*, *b*, *c*, *d* and *e* to make the pentagon.

3. Hexagon: six sides. Draw a circle. Using the same radius, mark off points *a*, *b*, *c*, *d*, *e* and *f* on the circumference. Join the points with straight lines.

4. Octagon: eight sides. Draw a circle. Draw the diameter *gc*. Bisect this at right angles to give *ae*. Open the compasses to a radius a little larger than a half of the quarter-circle arc. With the point of the compasses on *g* draw the arc *no*; with the point of the compass on *e*, draw the arcs *lm* and *rs*; with the point on *c*, draw the arc *pq*. Draw in the lines *jb* and *kh*. Join the points *a*, *b*, *c*, *d*, *e*, *f*, *g*, *h* and *a* with straight lines.

5. Decagon: ten sides. Draw a pentagon as at *No. 2* with a circle touching each corner. Bisect one side of this pentagon: with the point of the compasses at *f* and *d*, draw the arcs *mn* and *op*. Draw a line from *l* to the centre *k*. The points *ed* now give the length of each side, and this length is marked off round the circumference with compasses or dividers. Join all the points thus made with straight lines.

6. Duodecagon: twelve sides. Draw a hexagon as at *No. 3*. Bisect one side of this hexagon: with the point of the compasses at *g* and *e*, draw the arcs *qr* and *op*. Draw a line from *n* to the centre *m*. Points *fe* give the length of each side. Mark off this length around the circumference and join all the points thus made with straight lines.

PLATE 10. Star Shapes

These are most interesting shapes to draw and they can be used for many kinds of ornament and decoration large and small. They are much easier to draw than may appear. Once the principle of using a circle within a square is understood, the method is straightforward. The square simplifies the drawing in of the diameters of the circle at regular intervals. The points where the diameters touch the circumference become the points of the stars. Numbers of variations can be built up in this way.

1. Four-point star. Draw a square. Put in the lines to divide this square

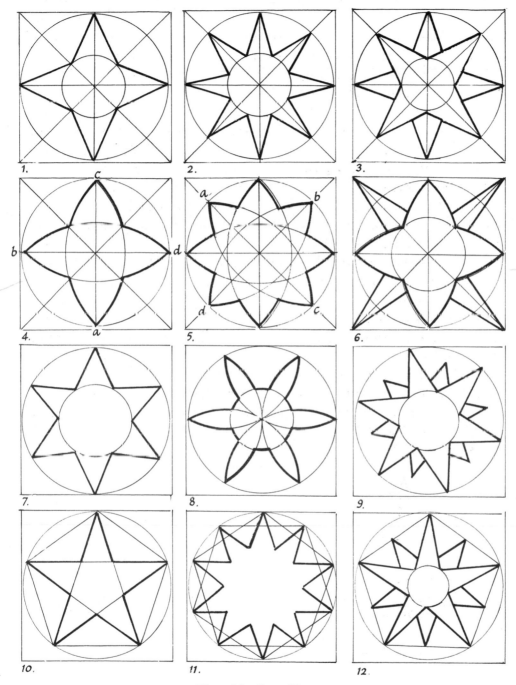

Plate 10. **Star Shapes**

into four small squares. Draw in the diagonals. From the centre of the square (where all the lines cross) draw a circle to touch the sides of the large square. Make a small circle inside this and join the points as shown by the thicker lines. The length of the star points will depend on the size of the inner circle.

2. Eight-point star. Draw as for the four-point star, and join the points as shown by the thicker lines. It will be seen that the base of each point comes on the small circle in the middle of the diameters: this can be judged by eye.

3. Eight-point star. This is another form made by placing a four-point star (*No. 1*) over another.

4. Four-point curved star. Draw the guide lines as for *No. 1*. Open the compasses to the radius *ab*, and draw in the arcs with the point on *a, b, c* and *d* in turn.

5. Eight-point curved star. Draw as for *No. 4*. Draw in additional arcs from points *a, b, c* and *d*.

6. Eight-point star from straight and curved lines. Draw as for *No. 4*. With the diagonals as a guide, draw in the straight line points, judging width of bases by eye. Divisions marked on the inner circle can be used to draw variations, such as the curved lines.

7. Six-point star. Mark off points around the circumference as for a hexagon. Do the same on the inner circle but so that each point comes midway between the points on the larger circle. Join the points to make the star.

8. Six-point petal-type star. Mark off points on the circumference as for a hexagon, but when doing so complete each arc.

9. Twelve-point star. This is drawn as for *No. 7*, and another smaller six-point star placed over this.

10. Five-point star. Draw a pentagon with the circle. Draw in the diagonals of the pentagon. The thicker lines show the finished star.

11. Ten-point star. This is made from two pentagons in reverse positions. To simplify the drawing of this type of star, make a pentagon template, and mark off the necessary points with this as a guide. A circle of the right size will also be needed as a boundary guide line for the points.

12. Ten-point star. This is also based on the pentagon. The points of the small rays are found by marking the centre of each side of the pentagon. The inner circle will govern the size of the rays.

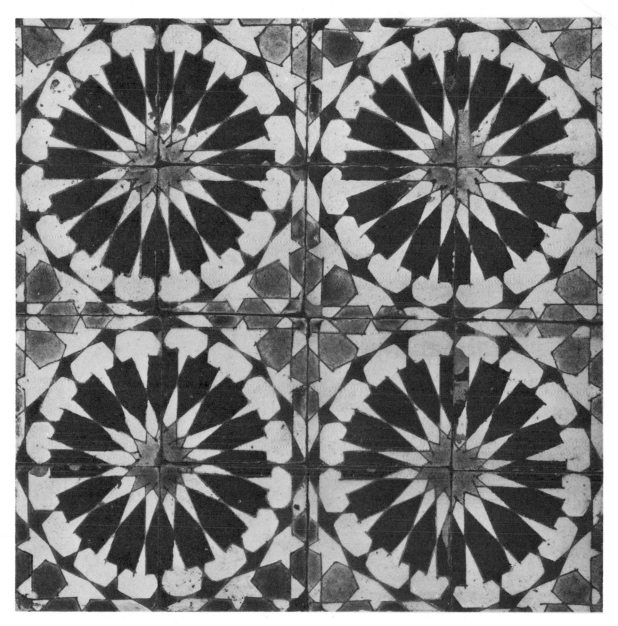

From a panel of sixteen earthenware tiles, Spanish, fifteenth century
By courtesy of the Victoria & Albert Museum

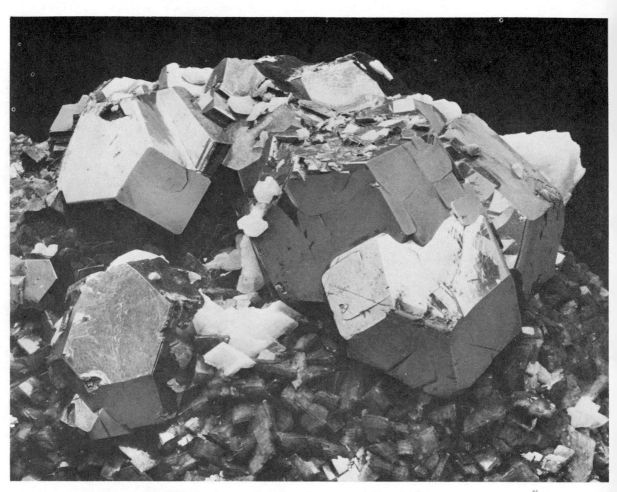

Geometrical pattern in nature: Galena, cubo-octahedral crystals
Crown copyright (*Geological Museum – Geological Survey HMSO*)

5 · Solid Figures

The ability to make models of solid geometrical figures follows from knowing how to draw the plane figures already described. These solids can be used to make interesting constructions, such as mobiles, for decoration.

Stiff paper, card or cardboard is used according to the strength needed. In order to make a clean and sharp bend, the material is scored where the bend is to take place. This is done with a knife, and care must be taken not to cut right through the material. Always bend the material away from the score-line, that is so that it comes on the outside of the model, as this makes a neater bend.

PLATE 11. Method of making solids—Tetrahedron

This is made from equilateral triangles and has four faces (or surfaces).

To make a tetrahedron with each face a triangle with three-inch sides, draw one large triangle with six-inch sides. Mark points at the middle of each side and draw in the triangle as shown by the dotted line in the illustration. Score along these dotted lines and bend to shape. Tabs for joining are positioned as shown by the thin lines.

NOTE: This and all the solids which follow can be made from separate pieces: it simply means that more joining has to be done. Templates are very useful for making these models, and were used for the more complicated models shown here. They save a good deal of time, but they must be measured and cut accurately. For example, a template of a triangle with three-inch sides can be made from card and four triangles traced round it to make the tetrahedron.

39

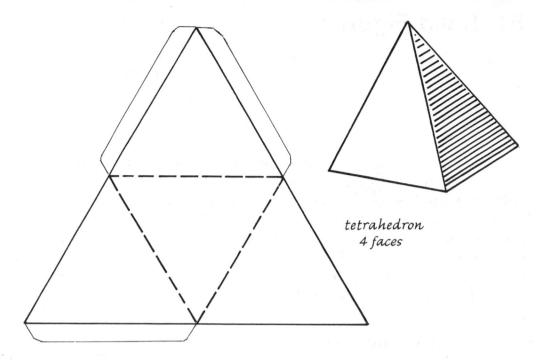

*tetrahedron
4 faces*

Plate 11. **Method of making solids—Tetrahedron**

PLATE 12. **Hexahedron**

This is made from squares and has six faces.

To make a hexahedron with each face a two-inch square, draw a rectangle eight inches by two inches and divide this into four equal squares. Add two more two-inch squares at the sides of this rectangle as shown. Score along the dotted lines and bend to shape. The tabs for joining are shown by the thin lines.

PLATE 13. **Octahedron**

This is made from equilateral triangles and has eight faces.

To make an octahedron with triangles having two-inch sides, make an accurate template from thin card of an equilateral triangle with two-inch sides. Trace round this to draw the outline shown. The dotted lines show the score lines, and the thin lines the position of the tabs for joining. Fold to give the shape shown.

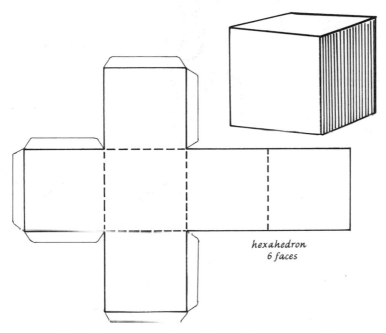

hexahedron
6 faces

Plate 12. **Method of making solids—Hexahedron**

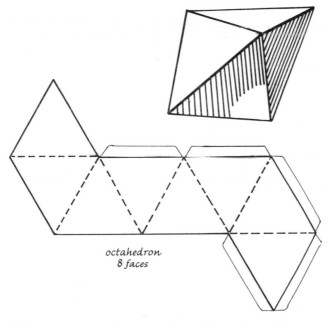

octahedron
8 faces

Plate 13. **Method of making solids—Octahedron**

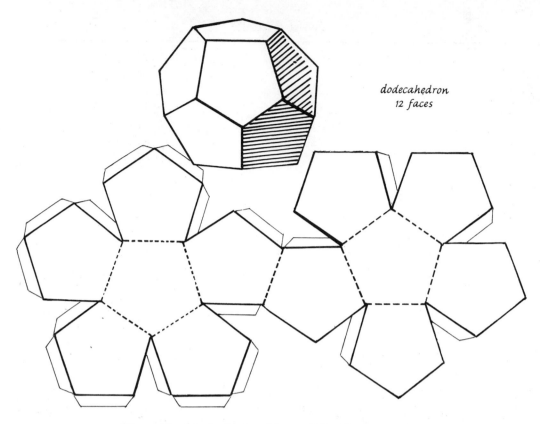

dodecahedron
12 faces

Plate 14. Method of making solids—Dodecahedron

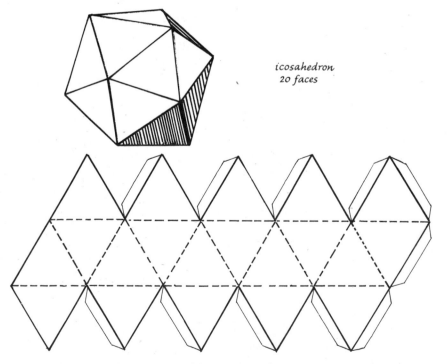

icosahedron
20 faces

Plate 15. Method of making solids—Icosahedron

PLATE 14. **Dodecahedron**

This is made from regular pentagons and has twelve faces.

Make a template of a regular pentagon from thin card and trace round this to give the outline shown. Score along the dotted lines and bend to shape. The thin lines give the position of the tabs for joining.

PLATE 15. **Icosahedron**

This is made from equilateral triangles and has twenty faces.

Make a template of an equilateral triangle from thin card and trace round this to draw the outline shown. Score along the dotted lines and bend to shape. The thin lines show the position of the tabs for joining.

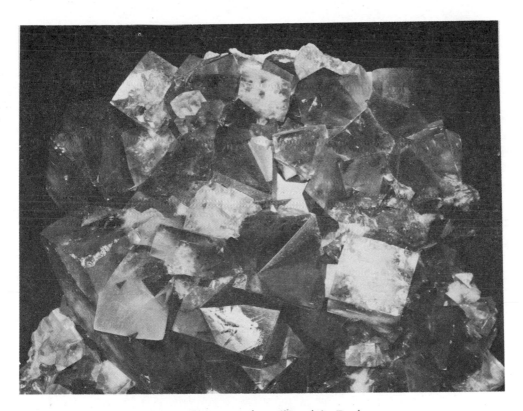

Geometrical pattern in nature: Fluor-spar from Weardale, Durham
Crown copyright (Geological Museum – Geological Survey HMSO)

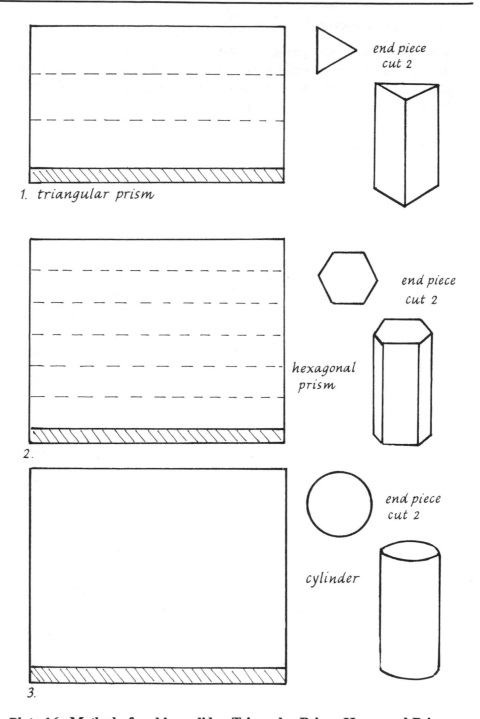

1. triangular prism

end piece cut 2

hexagonal prism

end piece cut 2

2.

cylinder

end piece cut 2

3.

Plate 16. **Method of making solids—Triangular Prism, Hexagonal Prism and Cylinder**

PLATE 16. **Method of Making Solids**

1. Triangular prism. This has two similar equilateral triangles for end-pieces and three sides.

To make the sides draw a rectangle whose width is three times the length of one of the sides of the triangle, and add on half an inch for joining purposes as shown. Score along the dotted lines and bend to shape. Glue the shaded portion (the extra half an inch) and secure. Add the endpieces.

2. Hexagonal prism. This has two similar hexagons as endpieces, and six sides.

To make the sides draw a rectangle whose width is six times the length of one of the sides of the hexagon plus a piece for joining purposes. Score as shown and bend to shape. Glue the shaded portion to secure. Add endpieces.

3. Cylinder. This has two similar circles as endpieces which are bounded by one side.

To make the side find the length of the circumference of the circle—approximately three and one seventh times the diameter. Draw a rectangle this width and add a piece for joining purposes. Glue the shaded portion but first check that the circle endpieces will fit accurately before securing. Add endpieces.

PLATE 17. **Method of Making Solids**

1. Cone. This has a circle as an endpiece and one side. To get the correct size for the cone shape, experiment first with stiff paper. Draw a semi-circle on this and cut it out. Wrap the curve of the semi-circle round the endpiece and mark the size at the base. Draw a line from this mark to the centre of the diameter from which the semi-circle was drawn. Add a sector for joining purposes and cut away the surplus paper. Use this as a template on card. Roll the card to a cone shape. Glue the shaded portion, but check first with endpiece for accuracy before securing and adding endpiece.

2. Hexagonal pyramid. This has a hexagon as an endpiece and six sides. Draw a semi-circle and with compasses or divider mark off the length of one side of the hexagon six times round the semi-circle and add a piece for joining purposes. Join each point with the centre of the diameter from which the semi-circle was drawn. Score along the dotted lines and bend to shape. Glue shaded portion and secure. Add endpiece.

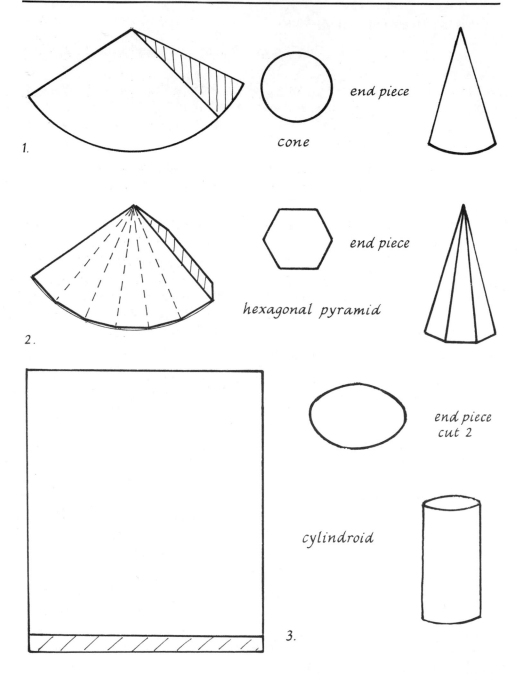

end piece

cone

1.

end piece

hexagonal pyramid

2.

end piece
cut 2

cylindroid

3.

Plate 17. **Method of making solids—Cone, Hexagonal Pyramid and Cylindroid**

3. *Cylindroid*. This has two similar ellipses as endpieces and one side. Find the distance around one of the ellipses by using a piece of stiff paper: wrap the paper round it and mark. Draw a rectangle whose width is the distance round the ellipse, and add a piece for joining purposes. Shape and check with endpieces before securing. Glue the shaded portion and secure. Add endpieces.

PLATE 18. **Making Spheres**

The simplest way of making these is by modelling tissue paper round a ball. A small solid rubber ball is very suitable. Use thin paste and two colours of tissue paper.

1. Cover the ball with a layer of Vaseline and tissue paper. This is necessary in order to remove the ball from the model afterwards. Paste on squares of tissue paper of one colour, overlapping each square and smoothing down as you go. The next layer is of the other colour tissue paper. Carry on for

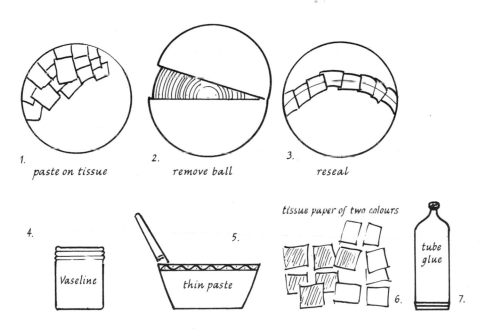

Plate 18. **Making Spheres**

about eight layers, alternating the colours to make sure of getting an even coverage. When all the layers are on, smooth everything over carefully, getting rid of any bumps or ridges.

2. When the paste and paper are quite hard, draw a line round the centre of the ball and cut round this with a craft tool or sharp penknife, but do not entirely separate the two halves. Remove the ball, which should come out easily because of the Vaseline.

3. Reseal by gluing round the cut with tube glue and then with two layers of tissue paper and paste around the join.

4, 5, 6 and *7* show the materials needed. Small bumps and ridges which remain after the model is dry can be smoothed out if necessary with fine glass paper.

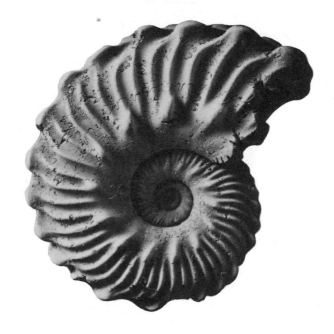

Geometrical pattern in nature: fossil Ammonite over 70 million years old, showing a patterned spiral. *By courtesy of the British Museum* (*Natural History*)

6 · Pattern Work with Plane Figures

PLATE 19. **Line Patterns**

These are easy but interesting patterns to draw. Those illustrated are based on the square, but line patterns can be based on any plane figure. Lines can also vary in thickness, spacing and type.

1. Pattern with horizontal and vertical lines. The square is first divided into four equal smaller squares.

2. Pattern with horizontal and vertical lines. The diagonals are drawn across the square as guide lines.

3. Pattern with horizontal and vertical lines. The diagonals and a circle are used as guide lines.

4. Pattern with horizontal lines. The square is divided into three equal rectangles and one diagonal is drawn in. Different spacing and thick and thin lines add interest.

5. Pattern with horizontal and vertical lines. The square is divided into three rectangles, the centre rectangle being larger than the other two, which are equal.

6. Pattern with horizontal and curved lines. The square is drawn and curved guide lines added by placing the point of the compasses in each corner of the square in turn.

7. Pattern from curved lines. The square is drawn and the diagonals drawn in as guide lines. The curves are made with the point of the compasses at each corner of the square in turn. Do not alter the radius of the compasses until four equal arcs are drawn.

8. Pattern with curved lines. Draw a square and divide it equally into smaller squares. Each square is then filled in the same manner, placing the point of the compasses in only one corner of each small square to draw the curves.

9. Pattern with curved lines. Draw a square and divide it into four equal

D

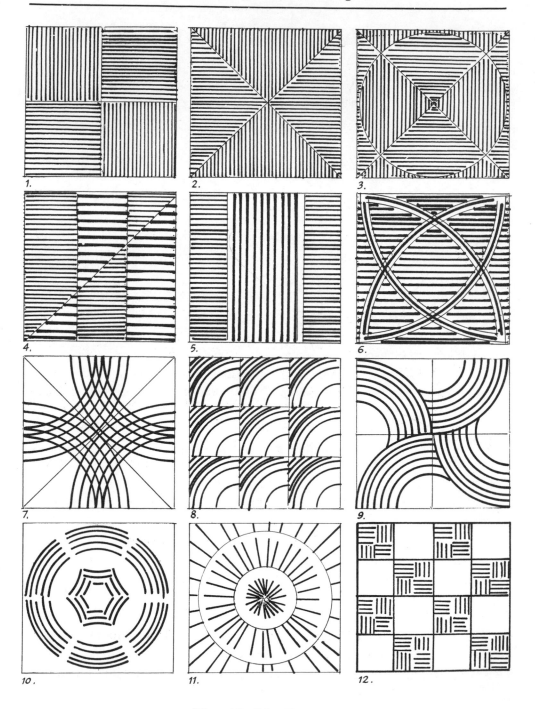

Plate 19. **Line Patterns**

smaller squares. The curves are drawn in by placing the point of the compasses on one corner of each small square.

10. Pattern with curved lines. The outside lines are broken circles. The inside lines are from small arcs in the reverse position.

11. Pattern with radiating lines. A square and circles are drawn as guide lines. Straight lines are then drawn to radiate from the centre and are broken to add interest.

12. An example of how a large pattern may be built up from single units.

PLATE 20. **Some natural divisions of the square**

There are some simple ways of dividing a square which seem to fall naturally into place to form pleasing shapes for pattern work.

1. The diagonals give four triangles.

2. The medians (middle lines) give four squares.

3. The diagonals and the medians form eight triangles.

4. A diamond within a square.

5. A diamond within a square with diagonals and one median.

6. A diamond with the median lines.

7. Two squares and two diamonds.

8. Square, diamond and a square within a diamond with its diagonals.

9. Square, diamond and a small square within the diamond with its medians.

10. Square and diamond, with the lines of the square within the diamond extended to touch the larger square.

11. A simple yet seemingly complicated pattern made from evenly reducing squares and diamonds.

12. An example of a large pattern made from small units of natural divisions.

PLATE 21. **The Square**

The thin lines act as guide lines for the construction of the pattern.

1. Pattern made on a network of squares.

2. Pattern similar to *No. 1* but using a larger network.

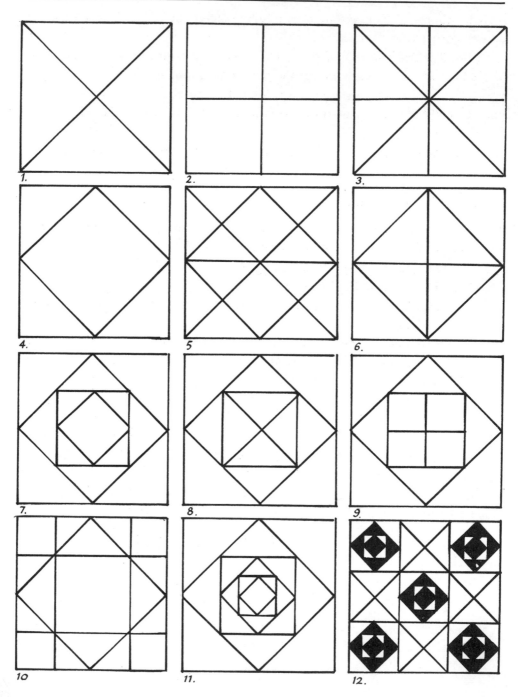

Plate 20. **Some natural divisions of the square**

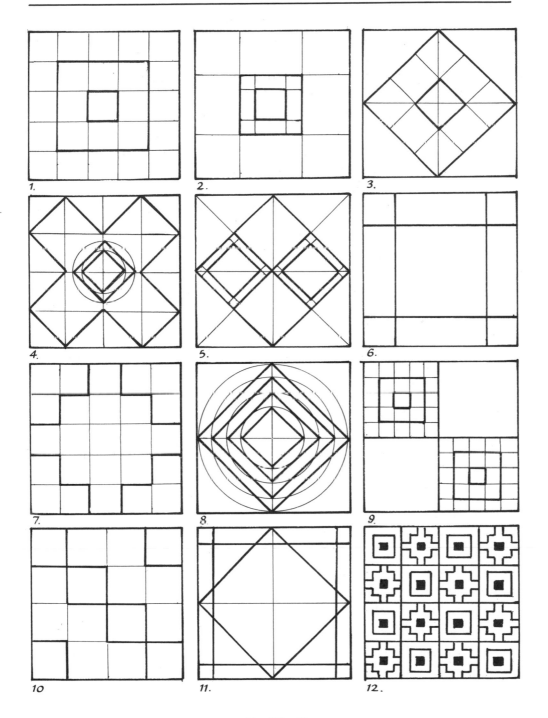

Plate 21. **The Square**

3. Method of drawing diamonds within a square.

4. A cross pattern based on a square network with circles as guide points for the inner ornament.

5. Diamond pattern based on diagonals and medians.

6. A border arrangement.

7. A step pattern based on a square network.

8. A reducing series of diamonds with circles acting as guide lines.

9. Check pattern with small squares based on small square network.

10. Step pattern based on a square network.

11. Border and diamond pattern.

12. An example of a large pattern made from two square pattern units.

PLATE 22. The Triangle

The triangle has an intriguing history as a symbol from earliest times. Among the ancient Greeks it was once the symbol of wisdom. In Egypt it was the hieroglyph for the moon. The Babylonians saw it as representing heaven, earth and air. And there were and still are many more interpretations of its form.

In the patterns drawn here the square has been used only as a guide. When the pattern is complete, all the thin lines should be erased.

1. The diagonals of the square form two equal isosceles triangles. Another large isosceles triangle is drawn over these forming other triangles within the pattern.

2. Two isosceles triangles form a unit which could become the outline for a border pattern.

3. The circle is marked off as for a hexagon to form a wheel-like type of triangular pattern.

4. A large triangle is drawn within the inner square and its sides extended to the large square to form three small triangles.

5. A pattern made from four overlapping triangles. Guide lines are very useful here in simplifying the construction.

6. A pattern of equal triangles placed one above the other. This forms an interesting unit for a large pattern.

7. Two isosceles triangles arranged to form a simple pattern.

8. A series of equal small triangles drawn within a large one.

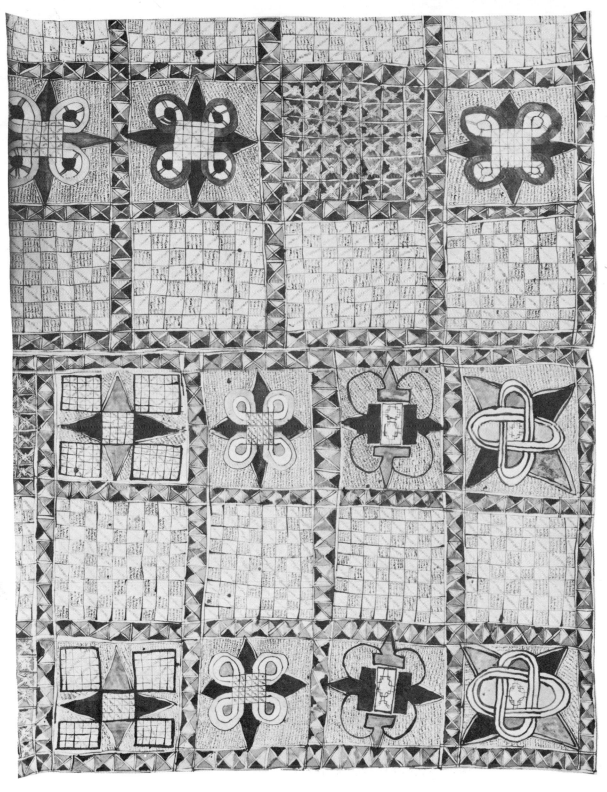

Ghanaian cloth with a painted design
By courtesy of the British Museum

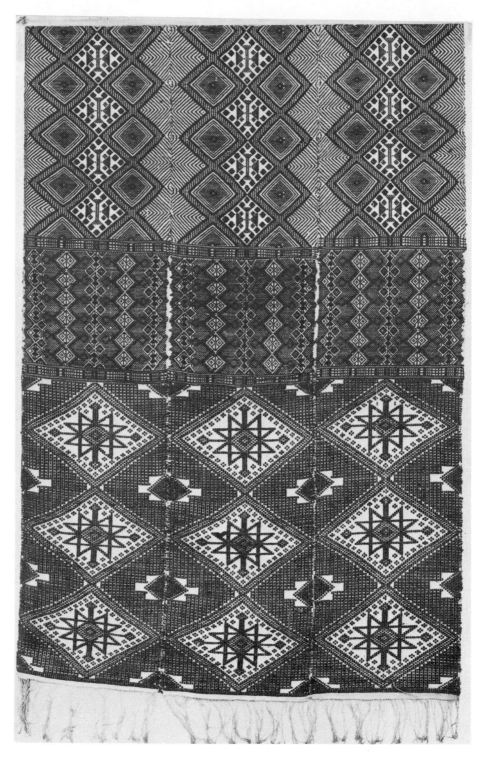

Black and white woven textile of cotton from Upper Senegal
By courtesy of the British Museum

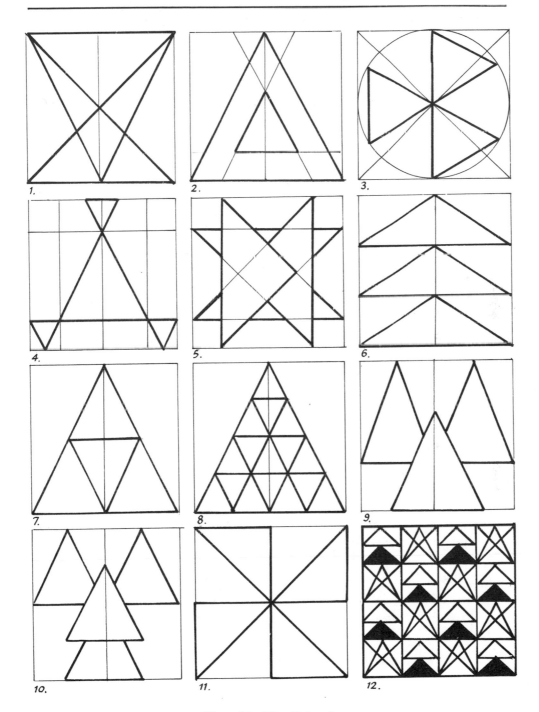

Plate 22. **The Triangle**

9. Another way of arranging three equal triangles which may be compared with *No. 6* to provide further ideas.

10. A pattern with four triangles. The four quarters of the square are drawn first. The centre triangle is placed on last.

11. Another wheel-type triangular pattern based on a square. The use of diagonals and medians make this easy to draw.

12. An example of a large, alternating pattern with units similar to *Nos. 1* and *6*.

PLATE 23. The Circle

The circle is perhaps the most useful of all shapes for a designer. It can be used in combination with all kinds of other shapes and makes an easy guide line in the drawing of other geometrical figures.

1. Pattern of four circles. A square is drawn and its diagonals ruled in. The centre for all the circles is where the diagonals cross. Draw in four circles: peek the point of the compasses at the same centre each time.

2. Pattern of circles and arcs from which an interesting cross pattern could be made.

3. Five-circle pattern. The centre circle is drawn first.

4. Pattern from circles and arcs. This could also become a cross pattern.

5. Pattern with four overlapping circles. The circumference of the thin small inner circle is the guide line on which the point of the compasses is placed at regular intervals in order to draw the four circles in different positions.

6. The small circles are centred on a thin inner circle which acts as a guide line with the diagonals and the medians.

7. Pattern with arcs and circles.

8. Pattern of curves within a circle. Regular intervals are measured along the diameter. The point of the compasses is placed on the circumference at each end of the diameter in turn and the curves made from the marked intervals.

9. Another version of *No. 5*. This looks difficult to draw but is quite simple. The thin inner circle is the guide line. The radius of the compasses is kept the same and the point is placed at regular intervals around the guide line.

10. Circle pattern with two outside circles forming a border.

11. Pattern with four circles decreasing in size with four small circles as added ornament.

12. An example of an alternating pattern made with the compasses.

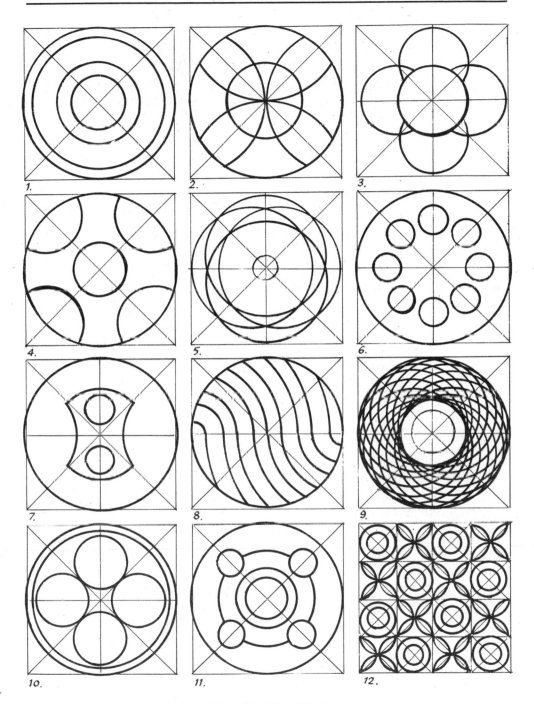

Plate 23. **The Circle**

PLATE 24. **The Pentagon**

This is another interesting shape but not used a great deal in ornament, probably because it is one of the more difficult to make. This difficulty is easily overcome in pattern work by using templates. The templates should be made as accurately as possible. A number of different sizes provide shapes and an easy method for drawing many unusual patterns. Templates were used for most of the pattern units shown here. When using templates, only one or two guide lines are necessary.

1. A pentagon within a pentagon. Once the outside pentagon has been constructed on a circle any number of smaller (or larger) pentagons can be drawn. Draw in the five radiuses from the common centre to the corners of the pentagon. Where each radius cuts a drawn circle will be the points from which to draw another pentagon.

2. This illustrates *No. 1.*

3. This is drawn as for *Nos. 1* and *2* but part of each radius is used to complete the pattern.

4. Pattern with two pentagons drawn with a template.

5. Pattern with four pentagons drawn with a template.

6. Pattern with three overlapping pentagons. Drawn with a template.

7. Pattern with one large and two small pentagons. Drawn with templates of two sizes.

8. Pattern with interlacing pentagons. Drawn with templates of two sizes.

9. Pattern with one large and four small pentagons. Drawn with templates of two sizes.

10. Pattern of a pentagon containing three smaller pentagons. Drawn with templates of two sizes.

11. A slightly more complicated pattern with one large pentagon containing three small pentagons. Drawn with templates of two sizes. The middle, irregular pentagon comes as a result of drawing the three inner pentagons.

12. An example of a band pattern made from small pentagon pattern units. In the second and fourth bands the diagonals of the pentagons are drawn in.

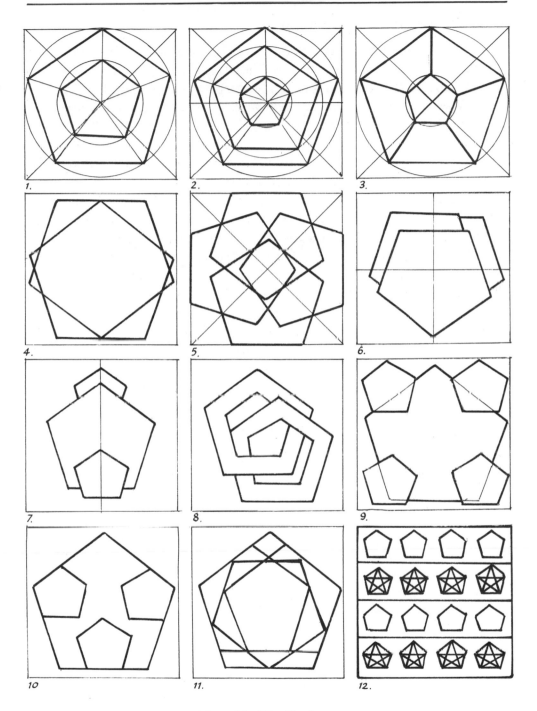

Plate 24. **The Pentagon**

PLATE 25. **The Hexagon and Octagon**

The hexagon is one of the most remarkable of all natural shapes. The honeycomb of the bee is made up of hexagonal cells. The hexagonal shape of the snow crystal in all its innumerable varieties provides the designer with an unending source of study. These crystals freeze at an angle of 60° which, as we know, is the angle of each radius of the hexagon. As they fall to earth they assume different patterns; some become starlike, others retain flat hexagonal shapes. They are so minute that a microscope is necessary to study their design. Many flowers also have their petals arranged in a hexagonal form.

A regular hexagon is a simple shape to draw with compasses and ruler, since the same radius used for a circle is used for marking the six points of the hexagon on the circumference. Templates give an easy method of pattern making.

1. A hexagon with a hexagon. The square provides a common centre with its diagonals and the circles form the base of the hexagons.

2. A hexagonal border with a small hexagon as the centrepiece. The diagonals of the outer hexagon together with the circles provide points and guide lines for the other hexagons.

3. Pattern with five hexagons. Drawn with a template.

4. Pattern with three overlapping hexagons. Drawn with a template

5. Pattern with three overlapping hexagons. Made with a template.

6. Pattern with four hexagons. Made with a template.

7. A complicated-looking pattern but easily drawn by using templates of two sizes.

8. Pattern with three hexagons. Based on three diminishing circles.

9. Pattern with four overlapping hexagons. The outer hexagon was made on the circle and the remaining parallel lines drawn in with a ruler.

10, 11 and 12. An octagon is shown here. Its shape is easily made on a network of squares.

10. An octagon pattern with a hexagonal centre and the diagonals used as part of the pattern.

11. An octagon pattern including a cross design.

12. An example of a large repeating pattern using *No. 11* as a unit.

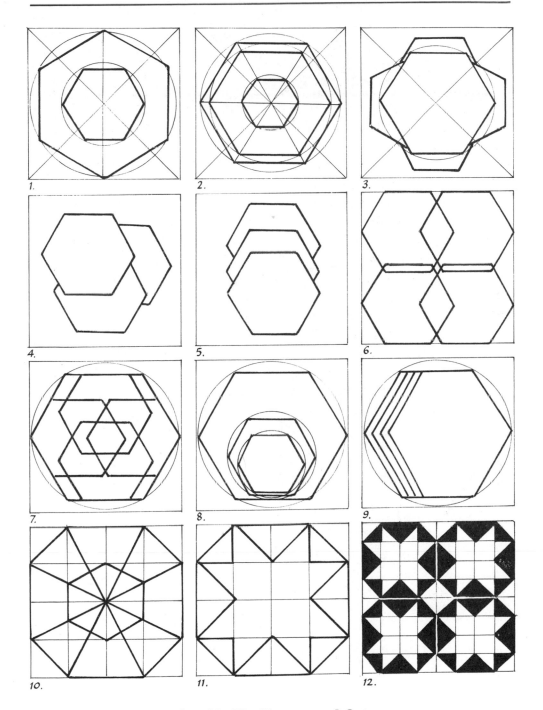

Plate 25. **The Hexagon and Octagon**

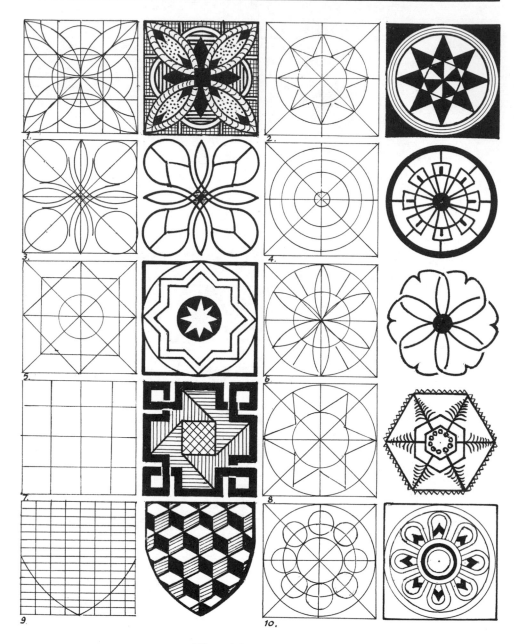

Plate 26. **Combinations**

PLATE 26. **Combinations**

The pleasure and interest of pattern-making really begin when different figures are combined to produce a design. Some examples are shown here: the guide lines are given on the left of the finished design.

1. A pattern from squares, semi-circles, arcs and an eight-point star.

2. Pattern from a square, circles and an eight-point star.

3. Pattern from arcs and circles.

4. A wheel pattern based on circles and diameters.

5. Star pattern with squares based on squares, a diamond and circles.

6. A petal pattern based on a hexagon. Finished with a little freehand drawing.

7. Pattern based on squares.

8. A snow crystal pattern based on a hexagon and its diagonals with some freehand drawing.

9. Counterchange pattern on a shield. Based on a network of small rectangles.

10. A wheel pattern in a square using circles, arcs and straight lines with a little freehand drawing.

PLATE 27. **Networks**

A network for pattern-making is made up of a number of lines arranged in regular steps. These lines form guide lines for the setting out of the pattern units in the desired order. When areas of pattern for linoleum, carpets and wallpaper, for example, are being planned the first drawing made consists of a network on which the pattern will be constructed. This ensures accuracy. Basic networks are the square and diamond networks. It will be seen that most of the others are based on these.

1. Square network. The drawing-paper is divided evenly into squares. Each square will take one pattern unit. The first three examples on Plate 28 illustrate the use of a square network.

2. Diamond network. The paper is divided first by the diagonals, which are at an angle of 45°. Other equally spaced lines are drawn parallel to these. This can be done by dividing each side of the paper into equal divisions and joining the points so that the lines drawn run parallel to the diagonals.

E

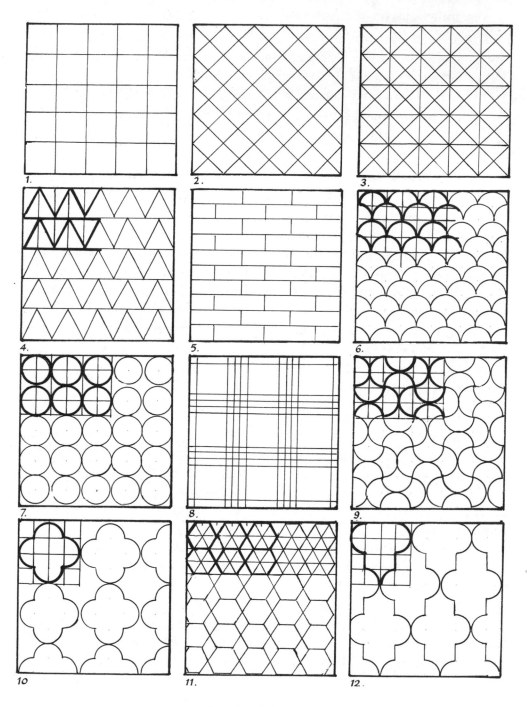

Plate 27. Networks

3. Square and diamond network. First draw a square network and draw the diamond network over this.

4. Triangular network. Different kinds of triangular networks can be drawn, depending on the kind and size of triangle. This one is based on an isosceles triangle drawn between parallel lines. The thick lines show how the triangles are made with the aid of a series of rectangles.

5. Rectangular network. The horizontal lines are drawn in first. The perpendiculars are then added. Various kinds of rectangular networks can be drawn.

6. Scale network. This is arranged in the form of fish scales, hence its name. The thick lines show how this network is based on a network of small squares. When the square network is ready the semi-circles are drawn in with compasses. The scales need not be circular, however.

7. Circular network. This also has a square network as its working base.

8. Plaid network. This is the foundation for a plaid or tartan pattern. The number of lines and their distance apart will vary according to the type of plaid.

9. Ogee network. This is a double ogee network. If you compare this with *No. 6,* you will notice that the semi-circles have been reversed or put back to back within six small squares. The position of each pair of semi-circles alternates from horizontal to vertical.

10. A quatrefoil network. Based on a square network four semi-circles form an enclosed figure.

11. Hexagonal network. Based on a diamond network crossed by horizontal lines.

12. Network from straight and curved lines. This shows how networks can be invented. Based on a square network and made up of straight lines and semi-circles drawn at regular intervals.

From the examples given above it will be seen that many other kinds of networks are possible. These will be based mostly on square or diamond networks. The aim of a network is to give good, clear outlines in which to place pattern units. The next plate (Plate 28) helps to illustrate this.

PLATE 28. **Some types of pattern**

Just as there are many kinds of networks so there are many kinds of pattern. The type of pattern used by a designer will depend on the article which is to receive the pattern.

1. Repeating pattern. The pattern unit is simply repeated. A square network was used.

2. Alternating pattern. There are two pattern units. Each follows each like the black and white squares on a chessboard.

3. Stripe pattern. Two pattern units are used here. Each is arranged in alternating columns.

4. Band pattern. Two pattern units are used. Each is arranged in alternating bands.

5. Drop pattern. A network is essential here in order to get the correct position of each unit. The main pattern units are placed at regular intervals of two or more squares vertically and horizontally. The intervals are decorated with another pattern unit which may consist simply of a dot or a small circle to form a kind of background for the main units.

6. Scale pattern. A scale network is constructed and each scale is patterned in the same way.

7. Plaid pattern. A plaid network is made to show the position of each line. Thick and thin lines are drawn at the required intervals on this. The spaces can be coloured to make tartan patterns. Tartan patterns were for many centuries the means of distinction among the various clans of Scotland.

8. Counterchange pattern. There is only one pattern unit. This is made to interlock and alternate in a light and dark colour. If you examine this pattern you will find that it is based on a network of zigzag lines. A series of zigzag lines is spaced equally across the paper from left to right; they are crossed by another series spaced the same way but going from top to bottom. The simplest form of a counterchange is a checker pattern.

9. Band pattern. This shows how a band pattern can vary. The wavy bands are based on a square network.

10. Interlacing pattern. Based on a diamond network crossed by horizontal lines. This is first worked out in pencil without any interlacement being shown. The unwanted lines are then erased and the final drawing made.

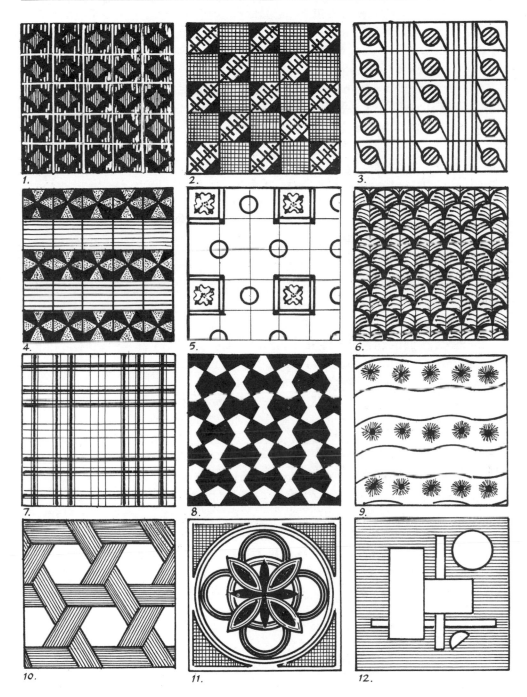

Plate 28. **Some types of pattern**

11. Enclosed pattern. This is a single pattern unit used by itself as a design. Such single patterns are sometimes seen on leather-covered books, in windows or on woodwork, for example.

12. Abstract pattern. This is the arrangement of geometrical shapes to form a pattern unit which allows the greatest degree of freedom. Although the unit would require a network for repetition if it were used, say, to decorate a material, what happens in its own small boundary depends wholly on the designer's sense of arrangement.

This by no means exhausts the range of patterns. Many more can be discovered or invented.

PLATE 29. **Borders**

Border designs on many different kinds of objects in all parts of the world often consist of simple geometrical patterns. Sometimes a border pattern is the only form of decoration on an object.

The border patterns set out here show the steps used in drawing them. Guide lines in pencil are drawn first. The pattern is then outlined in ink. After this the guide lines are erased and the pattern painted.

1. An overlapping diamond or square border. Guide lines are ruled in vertically and horizontally at regular intervals. The upright lines are placed so that the middle horizontal line and an upright form the diagonals of one diamond.

2. An overlapping circle border. Horizontal and upright lines are drawn in so that where they cross becomes the centre point from which the circles are made.

3. Diamond or square border. Horizontal and upright lines are ruled in at regular intervals. A diamond is constructed within a large square formed by these. The diagonals of the large square are drawn to divide the diamond into quarters. This is repeated at intervals and the diagonals are used as part of the pattern.

4. A border from circles and semi-circles. Horizontals and uprights are ruled in to give the centre points for circles. Semi-circles are drawn with the top and bottom of alternate uprights as centre points.

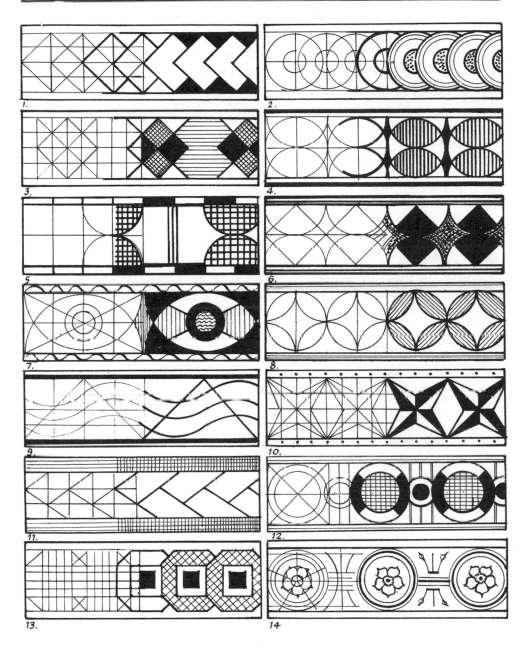

Plate 29. **Borders**

5. *Semi-circle and upright border*. Horizontals and uprights are ruled in to give points for drawing semi-circles. The semi-circles are repeated at regular intervals and the space between is divided by upright lines.

6. *Semi-circle and diamond border*. Horizontals and uprights are ruled in and are used for drawing the semi-circles and diamonds.

7. *Border from circles and semi-circles*. Based on a square network. A rectangle is made from a number of squares. Semi-circles are drawn from the top and bottom of the middle upright of the rectangles. Small circles are made where the diagonals·cross. The diagonals are used as part of the pattern.

8. *Border from circles and semi-circles*. A square net is made and the circles and semi-circles drawn on this.

9. *A wavy border*. A rectangular network is made. Single diagonals are drawn to form a zigzag line. Arcs are drawn in with the uprights providing the centre points.

10. *Gothic nail-head border*. A square net is drawn. This is divided into large squares and the diagonals are drawn in. The outline of the nail-head is then drawn by using the small squares as a guide.

11. *Interlacing border*. A rectangular net is made. The rectangles are then used for drawing in the diagonals.

12. *Circle and upright border*. Large squares are drawn with each square separated by evenly spaced uprights. A horizontal line is drawn in the centre through the length of the pattern. Diagonals are drawn in each square. The circles are then put in.

13. *An octagonal border*. The octagons are based on a network of small squares and rectangles.

14. *Line and circle border with a pentagonal inset*. A series of rectangles is made. Three concentric circles and two arcs are drawn in each rectangle. Two small circles are drawn inside the larger circles. Lines are drawn in at angles of 72° to give the pentagonal division. The flowers are completed freehand.

PLATE 30. **Frets**

Fret or key patterns were used a great deal by the ancient Greek and Roman craftsmen. A look at Greek vases will show that fret borders were a fairly common form of ornament. Roman mosaics also are often bordered with frets. Japanese frets are often used as pattern units.

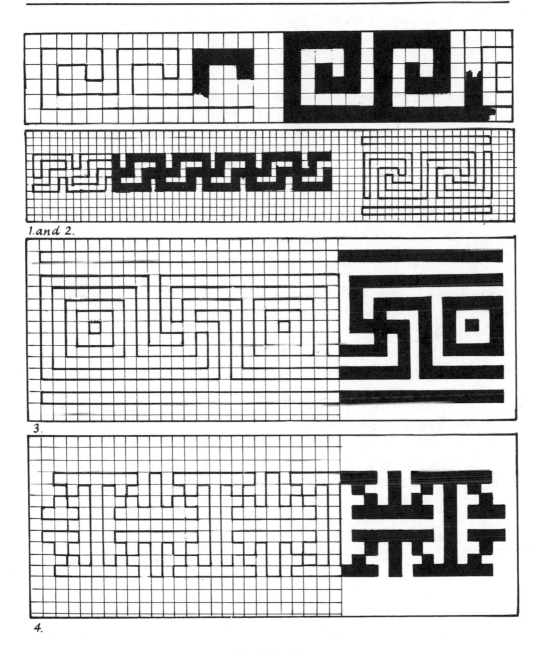

1. and 2.

3.

4.

Plate 30. **Frets**

They are all based on a net of small squares and seem fairly straightforward. However, it is easy to go wrong when making one.

First draw in the network in pencil, then shade in lightly in pencil the squares which make the pattern you want. This makes any correction simple.

1 and 2. This is the type of fret found on Greek and Roman ornament.

3. This is a more complicated form.

4. This is a Japanese type of fret. It will be seen that single pattern units can be made from these. These units can be placed in horizontal and vertical positions to make an interesting repeating pattern.

PLATE 31. Methods of enlarging and reducing

When copying patterns it may be necessary to make them larger or smaller to scale. There are several ways of doing this, and some of these are set out here.

1. Enlarging or reducing a rectangle. The diagonals are drawn across the rectangle. To make the rectangle larger the diagonals are extended beyond the rectangle. The compasses are opened to give the length of half the diagonal of the required rectangle, and a circle is drawn with its centre where the diagonals cross. Join the points on the diagonals where the circle cuts them. From the illustration it will be seen that a smaller rectangle is made in the same way, except that the diagonals do not have to be extended.

2. Enlarging or reducing a regular polygon. Find the centre of the figure and draw lines in to bisect each angle. To make the figure larger extend these lines beyond the given figure. With the point of the compasses in the centre of the figure draw a circle which will give the required size of the enlarged figure. Join the points on the lines where the circle cuts them. A smaller figure is made in the same way but the lines are not extended beyond the figure.

3. Enlarging or reducing a rectangle. A diagonal is drawn in the given figure. To enlarge this figure extend the diagonal and extend the base and one side of the given figure. Lines are then drawn parallel to the two remaining lines to meet at the diagonal. To reduce the figure only the diagonal need be drawn as a guide line.

4. Enlarging or reducing an irregular figure. Draw lines from a convenient angle to bisect as many of the other angles as possible. To enlarge the figure extend these lines; also extend the lines which form the angle from which the bisecting lines were drawn. All these lines now form guide lines for drawing

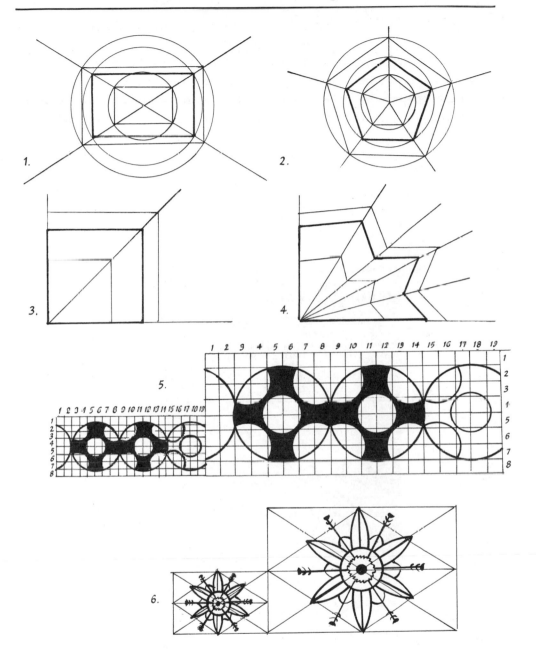

Plate 31. **Methods of enlarging and reducing**

lines parallel to the given figure. Similarly the figure can be reduced, except that it is not necessary to extend any of the guide lines.

5. *Enlarging or reducing drawings.* Draw a square net over the drawing. Number these squares. Draw the same number of squares, either larger or smaller as required. Number these squares to correspond with the first set. By using the figures as a cross-reference the drawing can be copied on to the second set of squares.

6. *Enlarging or reducing drawings.* Draw a rectangle to enclose the drawing. Put in the diagonals and median lines. Draw in the diagonals in the four small rectangles thus made. This gives a number of guide lines which can be increased if necessary by simply repeating the process. To copy the drawing draw a rectangle with the same guide lines to a larger or smaller scale.

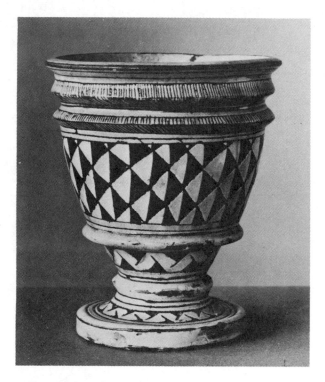

Italian goblet, about 1520
By courtesy of the Victoria & Albert Museum

7 · Pattern Work with Solids

The following photographs show the solids on Plate 5 made up into pattern units. These can be used as single units for decoration or arranged in groups as mobiles or stabiles.

These shapes can be covered with a patterned paper, using some of the geometrical patterns already suggested. Wallpapers, bought decorative papers, gummed coloured papers and metallic papers and foils are all useful for covering models of solid shapes.

Various kinds of paint ranging from water colours to household paints can be used for surface decoration.

Metallic powders can be applied as a covering as follows. Place a small quantity of the powder in a saucer, and have a drinking-straw handy. Cover the model with a thin coat of glue—or this can be done one surface at a time depending on the size of the model. Let the glue be tacky. Blow the powder carefully on to the sticky surface by blowing through the straw. Have a sheet of newspaper under the work to catch any loose powder. The model can be held in position by pushing a thin piece of wire into a wooden base and then either shaping the wire to hold the model or by sticking the wire into the model.

Photograph 1: Tetrahedra. One large model was made and four small ones (Plate 11, page 40). These were decorated and the small tetrahedra glued, one on each surface, to the large one.

Photograph 2: Hexahedra. One large and six small hexahedra were made (Plate 12, page 41). These were covered with a decorative paper. A small one was then glued on each surface of the large hexahedron.

Photograph 3: Octahedra. Three octahedra were made (Plate 13, page 41). They were then decorated. A length of reed was pushed through the models and secured with cotton.

Photograph 4: Dodecahedra. Three models were made (Plate 14, page 42). They were covered with gummed coloured paper. A length of reed was then

77

pushed through the models and one end of the reed put through a slit in the other end.

Photograph 5: Icosahedra. Three icosahedra were made (Plate 15, page 42). They were decorated, and a thin length of galvanized wire was put through each shape. Beads were used to separate the shapes and to hold the bottom shape in position. The bottom end of the wire can be flattened slightly with pliers in order to secure the bead.

Photograph 6: Triangular prisms. Three triangular prisms were made (Plate 16 (*1*), page 44). These were decorated and hung from a piece of reed. Beads were used as an additional decoration.

Photograph 7: Hexagonal prisms. Three hexagonal prisms were made (Plate 16 (*2*), page 44) and covered with wallpaper. Reed was then used to hold them together.

Photograph 8: Cylinders. Three cylinders were made (Plate 16 (*3*), page 44). These were then covered with a decorative paper. A length of thin wire was pushed through each shape, and beads were used to separate the shapes. The last bead can be secured by flattening the end of the wire.

Photograph 9: Cones. Four cones of the same size were made (Plate 17 (*1*), page 46). These were covered with decorative papers. Wire was threaded through the cones and beads used as an additional decoration.

Photograph 10: Hexagonal pyramids. Three pyramids were made (Plate 17 (*2*), page 46). A small circle was removed from the base of each and they were glued to a table-tennis ball.

Photograph 11: Cylindroids. Three models were made (Plate 17 (*3*), page 46). These were joined together with reed.

Photograph 12: Spheres. Spheres were made from tissue paper (Plate 18, page 47). These were left rough and painted, and then strung on a spiral of wire.

Many other units are possible, either of the same shapes or a combination of shapes. There is a good deal of room for inventiveness. One variation would be to cut away part of the shapes to produce frameworks instead of solids. In this way shapes such as the tetrahedron might be hung one within the other. Another variation would be to use half- or quarter-shapes.

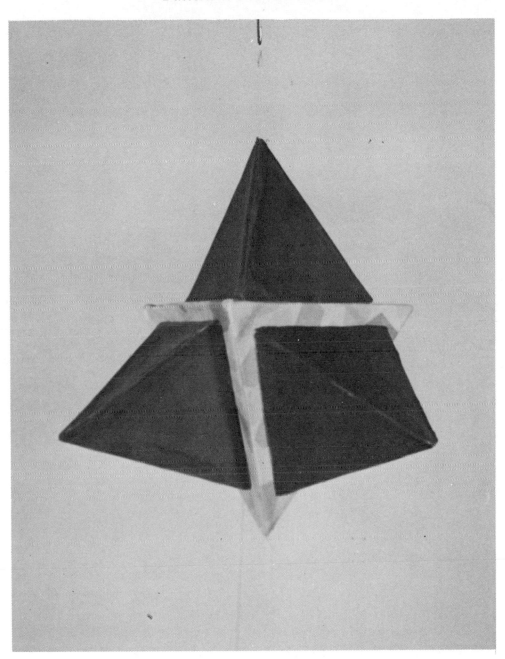

Photograph 1. **Tetrahedra**

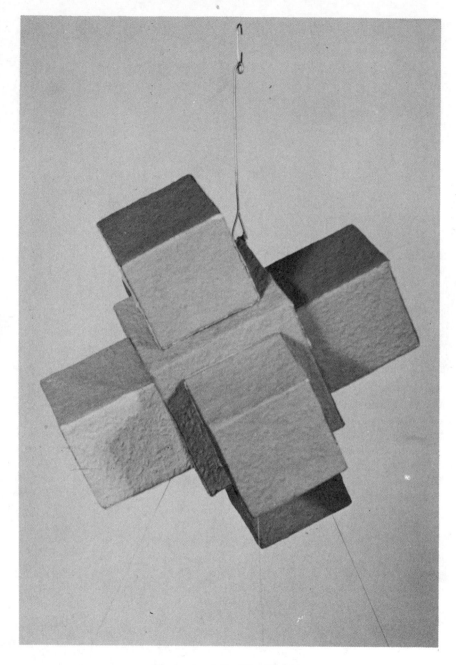

Photograph 2. **Hexahedra**

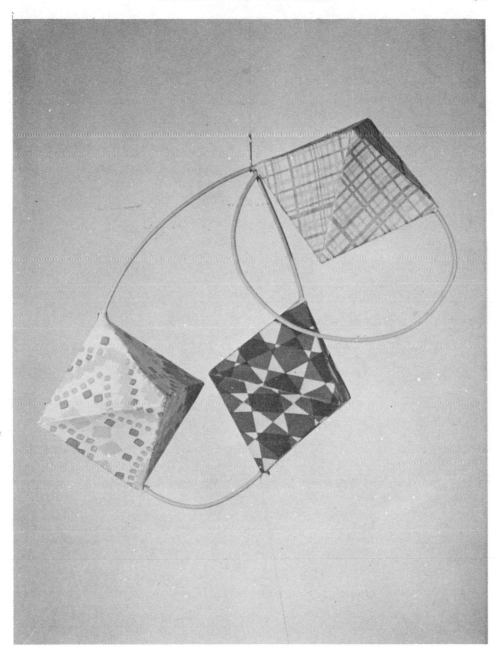

Photograph 3. **Octahedra**

F

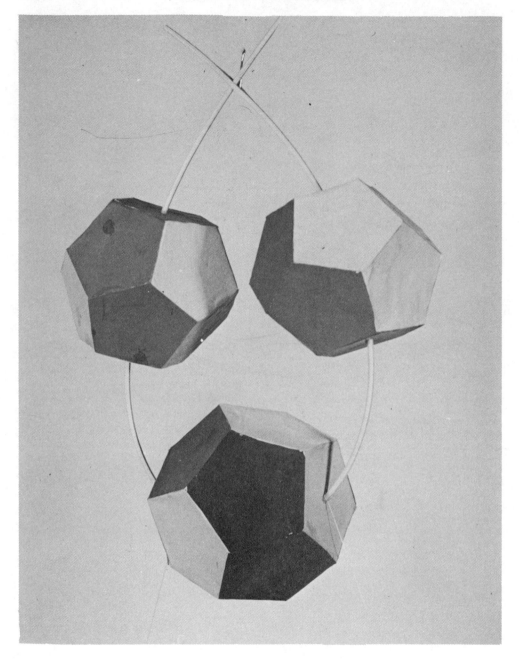

Photograph 4. **Dodecahedra**

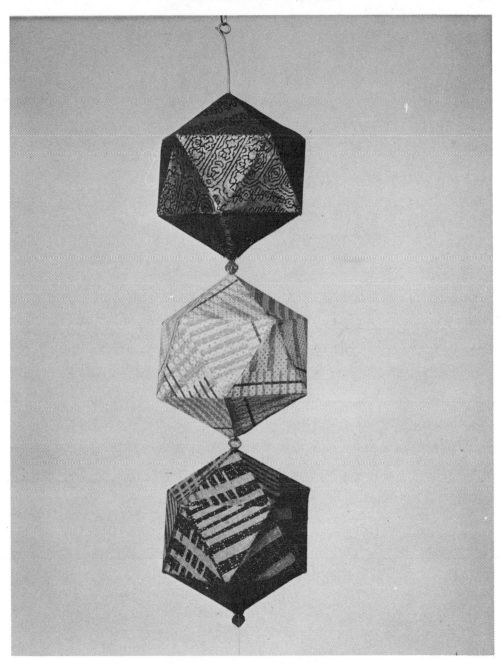

Photograph 5. **Icosahedra**

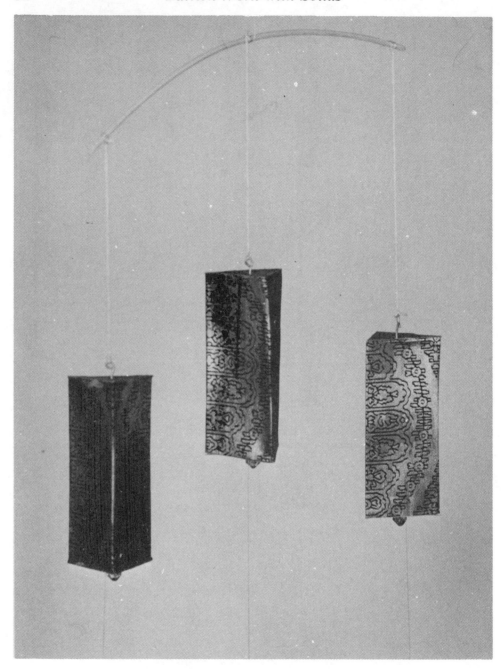

Photograph 6. **Triangular prisms**

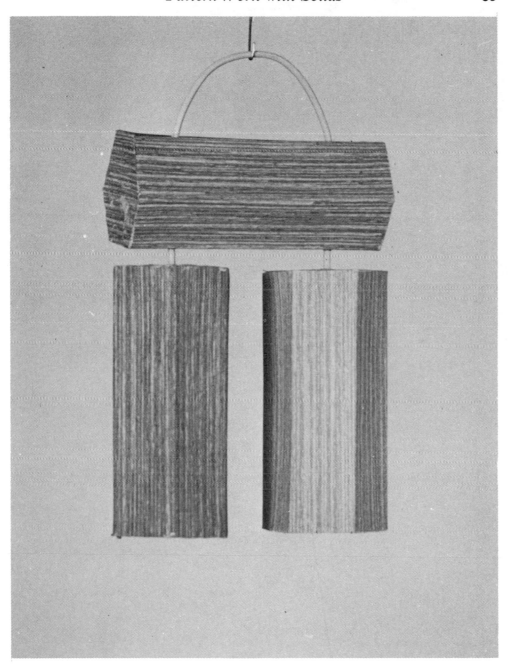

Photograph 7. **Hexagonal prisms**

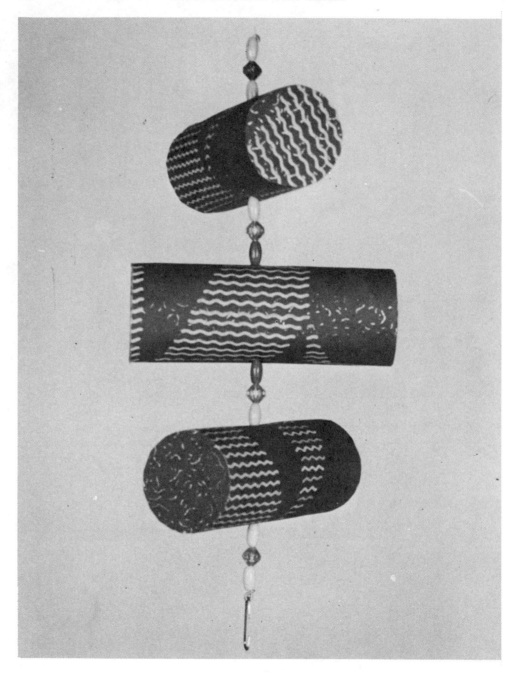

Photograph 8. **Cylinders**

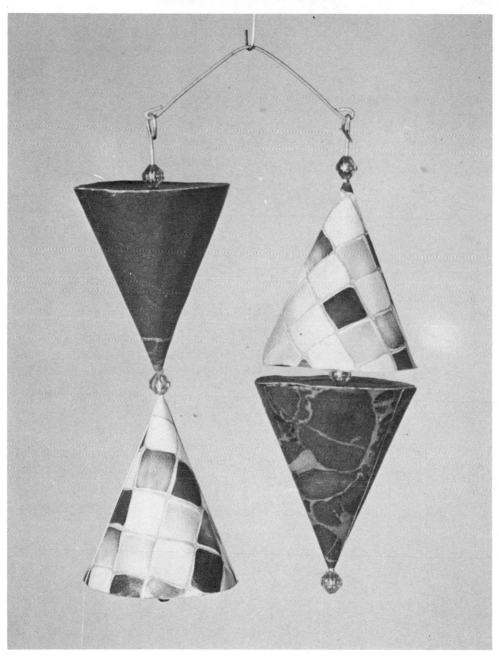

Photograph 9. **Cones**

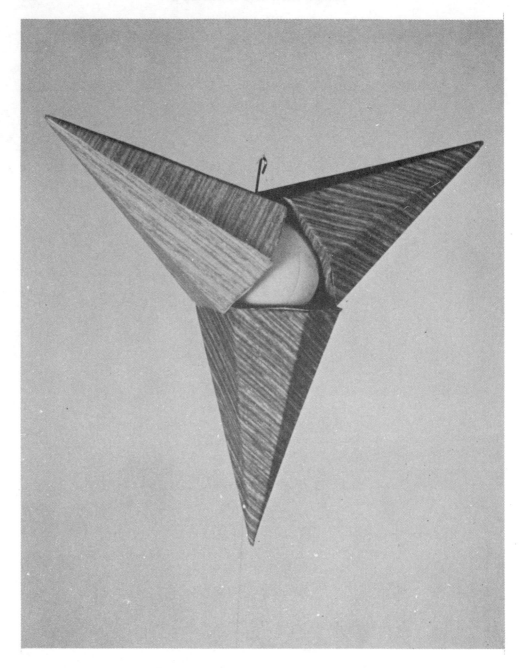

Photograph 10. **Hexagonal pyramids**

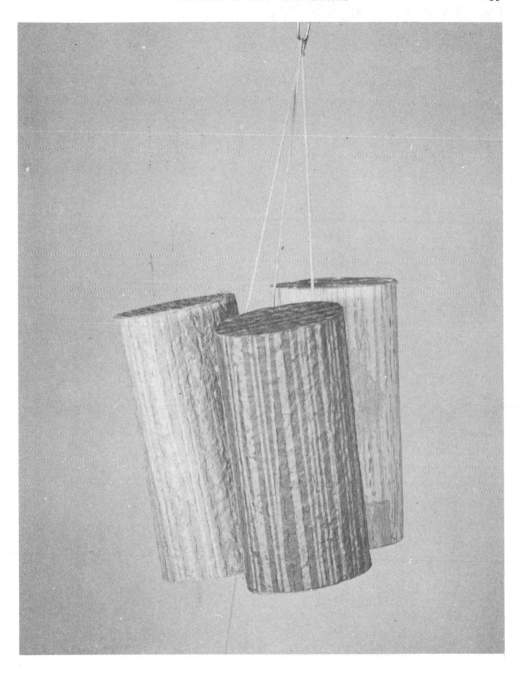

Photograph 11. **Cylindroids**

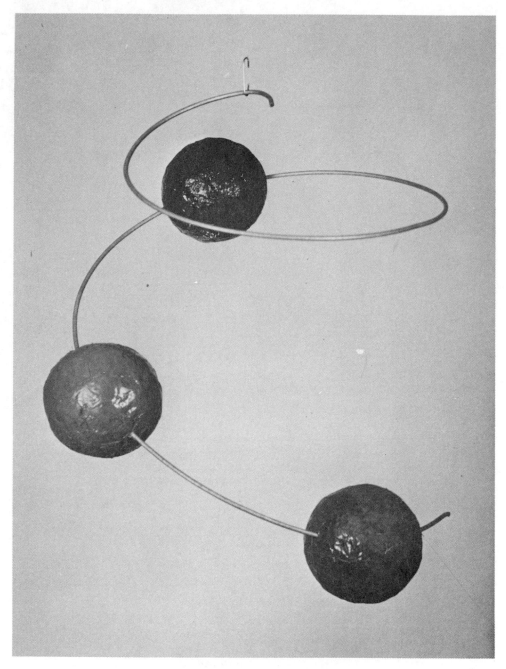

Photograph 12. **Spheres**

8 · Further Study

There are many good textbooks on geometry, and most public libraries have a selection of these. Even if the mathematical side of geometry does not appeal to you it is well worth studying these books in order to obtain ideas for pattern work. Books on mechanical and technical drawing also contain many figures which may stimulate ideas.

For those who become interested in technical drawing a good little introduction to the subject is *Foundations of Technical Drawing* by A. C. Parkinson, published by Isaac Pitman and Sons, London, reprinted in 1966.

Hornung's Handbook of Designs and Devices, a Dover paperback, contains nearly two thousand designs based on geometrical figures. Some of these are intricate and many a pleasant hour can be occupied in discovering how to draw the designs for yourself, following the method of using basic figures such as the square and its diagonals and the circle as guide lines, as set out in this present book.

There are many patterns in nature which are either geometrical or can be put into geometric form. Many wild flowers, for example, have a pentagonal shape. The wood sorrel, the buttercup, the tiny flowers of the elder, the campion and other familiar flowers have a five-petal design. Others have hexagonal and star-like forms. It makes an interesting hobby to go directly to the fields and hedges to study the shapes of wild flowers, but if you cannot do this there are many books on wild flowers that contain illustrations. *Common Wild Flowers* by John Hutchinson, a Pelican book, has illustrations very suitable for adaptation to geometrical pattern work. *Snow Crystals* by Bentley, Wilson and Humphreys was first published in America in the nineteenth century. It has been reprinted recently as a Dover paperback. The wonderful variety of hexagonal shapes shown in photographs provides the designer with plenty of material for ideas. *Patterns in Space* by Richard Slade, published by Faber and Faber in 1969, shows how to make constructions of a geometrical nature from various materials and suggests sources for further ideas.